The Simple Art of Japanese Calligraphy

The Simple Art of Japanese Calligraphy

A step-by-step guide to creating
Japanese characters with
15 projects to make

Yoko Takenami

CICO BOOKS
LONDON NEW YORK

This edition published in 2023 by CICO Books
An imprint of Ryland Peters & Small Ltd

20–21 Jockey's Fields 341 E 116th St
London, WC1R 4BW New York, NY 10029

www.rylandpeters.com

10 9 8 7 6 5 4 3 2 1

First published in 2004

Text © Yoko Takenami 2004
Design, illustration, and photography © CICO Books 2004

A CIP catalog record for this book is available from
the Library of Congress and the British Library.

ISBN: 978 1 80065 225 5

Printed in China

Edited by Robin Gurdon
Photographs by Geoff Dann
Design by Ian Midson

MIX
Paper from
responsible sources
FSC® C106563
FSC
www.fsc.org

CONTENTS

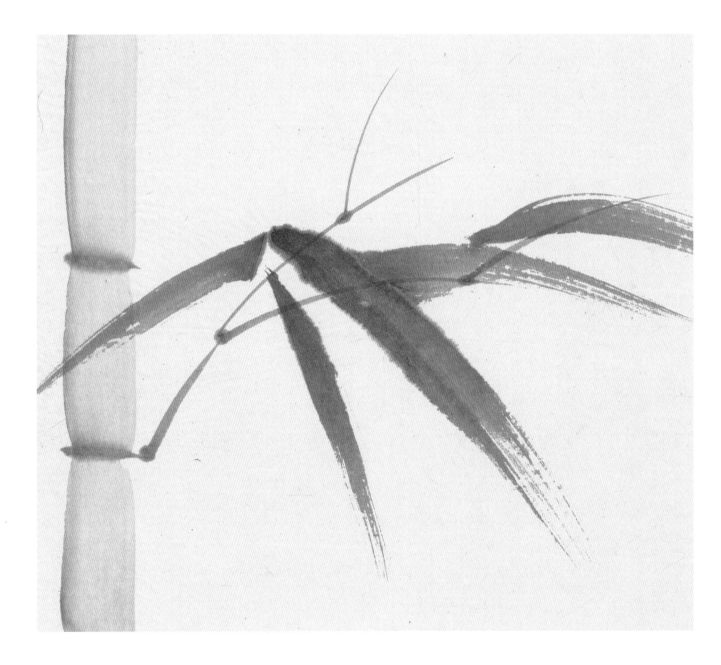

FOREWORD

I am delighted that Miss Yoko Takenami has written *The Simple Art of Japanese Calligraphy*. I have known her since her primary school days and saw her show talent even then in calligraphy. She kept up her calligraphy study through all her varied education, and now, having spent some time working in an international environment, she is able to realize the beauty of Japan once again.

Japanese calligraphy is not simply an art in itself, but also includes the strengths of religion, philosophy, literature, and history, and if this book helps the people of the world to find some good aspect of the Japanese people and culture, as a Master I can say the author's hard work is worthwhile.

Kakko Nishii

Kakko Tsuruka

INTRODUCTION

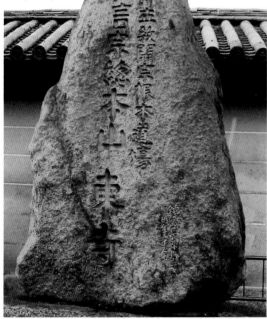

Right: This calligraphy carving in stone sits at the entrance to Toji Temple.

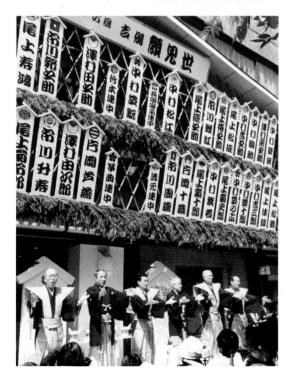

Calligraphy, just like any other form of art, reflects the artist's state of mind: what is written on a sheet of paper, cloth, or piece of wood shows the personality of the work's creator. It is said, "Your writing reflects your personality." This is why the Japanese name for calligraphy is *sho do*, which most directly translates as "way of writing"—in the same way that flower arranging is known as *ka do* (way with flowers) and the tea ceremony is *sa do* (way with tea).

What makes calligraphy very special is that it is an art of the moment: you can create a stroke only once and, in wanting to capture the moment, calligraphy requires special concentration. Strokes are works of art in themselves; you can never correct a mistake once it has been made. Although calligraphers through the ages have sought inspiration from the ancients, calligraphy never involves merely copying the works of old masters. For everyone who practices calligraphy, each stroke and each character is a reflection of his or her own spirit.

Japanese calligraphy also reflects the country's cultural history. Its development started when sets of characters (*kanji*) were imported from China alongside Buddhism and Confucianism in the sixth

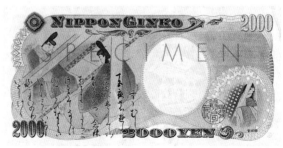

Far left: Calligraphy actors' signs flutter above players celebrating the start of the Kabuki season. Left: This copy of a 2000-yen note shows a picture of the "Tale of Genji."

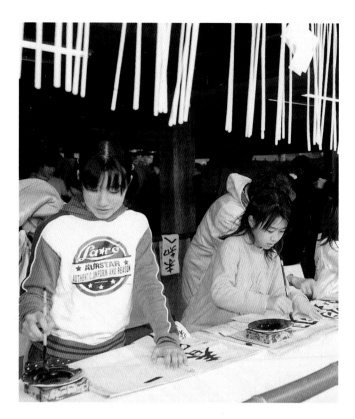

Left and above: Japanese children and adults celebrate the annual New Year Calligraphy Ceremony, organized by a calligrapher's association (above) and by a shrine in Kyoto (left).

century AD. As these influences grew in everyday life, the process of making a Chinese writing system fit the Japanese language resulted in the creation of a uniquely Japanese group of phonetic characters, known as kana. Nowadays, two sets of *kana*—*hiragana* and *katakana*—are used in Japan. The transition was not easy but, as a result, a rich variety of Japanese calligraphy can now be enjoyed, using the Japanese *kana* alphabets as well as the original Chinese *kanji* characters.

In the highly advanced world of technology in which we now live, if calligraphy involved nothing more than the writing of characters, the art would soon become obsolete. However, Japanese calligraphy is also a discipline that strengthens our inner self. A form of art whose influence is deeply embedded in Japanese everyday life, calligraphy is still taught in Japanese schools and adults show increasing eagerness to learn it.

This book introduces the wonders of Japanese calligraphy and shows you how to create the three basic sets of characters in use today in Japan—the Chinese *kanji* characters, which represent an entire word visually, and the two phonetic alphabets, *hiragana* and *katakana*. With exercises that show you how to "master the brush," and 15 beautiful paper, ceramic, and fabric projects, you will soon be ready to enjoy the spirituality and elegance of the art in your everyday life. I hope you'll enjoy the process of immersing yourself into calligraphy so that each of your works becomes a "moment of writing yourself."

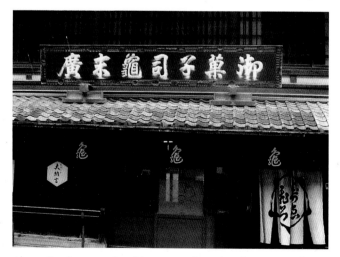

Above: Two fine examples of Japanese calligraphy adorn a sweet shop in Kyoto: the sign in wood and the hanging curtains at the entrance.

HISTORY

Calligraphy is now enjoyed and appreciated as a form of fine art, but it began as a simple means of communication, first developed many thousands of years ago in ancient China as a system of pictograms.

The first *kanji*, or Chinese pictogram, characters are believed to have arrived in Japan as early as in the first century AD, on a seal given by the Chinese Emperor Khuang Wu to the king of Na, as the state of Japan was then known by China. The first recorded Chinese characters written by Japanese people are believed to be an inscription on a sword found in the ancient Eda Funayama tomb. Early works of calligraphy were carved, not written. Before paper was invented by the Chinese around 200 BC–AD100, materials used for writing included stone, metal, and bone.

When Buddhism and Confucianism were introduced to Japan around the sixth century AD, more Chinese calligraphy entered the country. These pieces were mostly sutras (Buddhist chants or mantras) and commentaries, written in a variety of scripts using brush and ink on paper. The earliest extant handwritten text by a Japanese calligrapher is thought to be a sutra known as the *Commentary on the Lotus*, which is purported to have been written by Prince Shotoku (574–622), a regent to Empress Suiko. It is written in the clerical, cursive style that was current in China from 400 to 600. During the Nara era (714–794), the copying of sutra grew in popularity;

Left: The Eda Funayama Tomb Sward. Carved in the 5th century, this is one of the first recorded examples of Japanese calligraphy inscribed by a Japanese.

Right: An 8th-century example of *shakyo*—the sacred copying of a *sutra*—named Junsei Riron.

Left: Fu Shin Jo, written in the 9th century by Kukai, or Kobo Daishi, one of the best calligraphers of his day and still considered a master. Kukai was influential in developing the beginning of a distinctly Japanese style of calligraphy. This celebrated work is the first of three pieces addressed to his rival priest, Saicho.

the Shakyojo, or Sutra-copying Bureau, was established in the capital city of Nara by the Emperor. In 607, Japan began sending monks to China to study Buddhism, and the practice, named *kentoshi*, lasted until the late ninth century. Monks who traveled to the China of the Sui dynasty (589–618) and the Tang dynasty (618–907) returned to Japan with the latest fashions and cultures, including new developments in calligraphy.

Japanese calligraphers were most influenced by the calligraphers working in the Tang capital city, Changan, which was enjoying a golden age of calligraphy. The standard block style, or *kaisho*, script developed by Changan calligraphers such as Chu Sui Liang (596–658) was the most enduringly popular, and many beautiful sutra in *kaisho* survive even today.

One traveling monk, Kukai (774–835)—known as Kobo Daishi—returned to Japan and founded an esoteric Buddhist group known as the Shingon Sect. Kukai also studied many styles of calligraphy and created his own.

It was at this point that an independent Japanese style started to develop. As a member of the artistic group The Three Brushes (*Sampitsu*), alongside the Emperor Saga (786–842) and the courtier Tachibana No Hayanari (who died in 842), Kukai was regarded as one of the three best calligraphers of the time. Although they were heavily influenced by Chinese calligraphy, Japanese calligrapahers started to create their own, unique style. Kukai is known to have mixed the styles of two Chinese masters, the standard style of Wang Xi Zhi (303–361) and the more forceful style of Yan Zhen Qiag (709–785).

The establishment of Japanese calligraphy as a distinct art form, rather than one that simply copied Chinese styles, grew firmer in 894, when the practice of sending Buddhist monks to China was abolished. This new insularity encouraged the development of a uniquely Japanese culture. During the tenth century, writing shook itself free from Chinese ways and transformed itself into an elegant style based purely on the Japanese esthetic, with

Above: Aki Hagi Jo attributed to the 10th-century calligrapher Ono No Tofu. He wrote 48 poems in *sogana*, a transitional form between *kanji* and *hiragana*.

more emphasis on roundness, flow, and harmony. This was the time of the The Three [Brush] Traces (*Sanseki*)— Ono No Tofu (894–966), Fujiwara No Sukemasa (944–988), and Fujiwara No Yukinari (972–1028).

Not only was the style of Japanese calligraphy changing, but this period also saw the creation of the written Japanese language. The major development at this time was the introduction of *kana*—a group name for a number of syllabic writing systems developed in Japan, deriving from *kanji*. While *kanji* characters are pictograms, expressing the meaning of individual words visually, *kana* characters are phonetic. The word *kana* derives from *kari*, which means "irregular" or "temporary," and *na*, which means "name" or "writing," expressing the feeling that using Chinese characters for their pronunciation but not for their meaning was "irregular" for the Japanese language.

Two sets of *kana* are used in the present-day Japanese writing system. *Hiragana* is a rounded, flowing, cursive script and is most commonly used for writing native Japanese words and any words of Chinese origin that are not written in *kanji* characters. *Katakana*, a spiky, non-cursive script, can be used in place of *hiragana*, but it is most typically used to write words adopted from other languages, as well as Western names, trade names, and greetings.

Both *hiragana* and *katakana* derive from an early *kana* script named *manyogana*, which was created in the eighth century as a result of trying to adapt the Chinese writing system to the Japanese language. Unlike modern-day *hiragana* or *katakana*, a number of *manyogana* were used to represent one sound. Known as the script of "ten thousand leaves," *manyogana* is a set of unmodified

Chinese characters that are transformed into phonetic symbols representing Japanese syllables.

Manyogana developed into the sogana script, which is written in the *sosho*, or cursive, style. *Sogana* is regarded as the transitional form between *kanji* and the 46-character script used in Japan today. It was in use until 1900, when the *kana* system in Japan was standardized into 46 *hiragana* and *katakana* characters. Nowadays calligraphers only use *sogana* to express their emotions through its beauty and variety.

In the imperial Japanese court world, *kana* writing developed into what was known as *onna–de* ("women's writing"). Soft, elegant, and flowing, *onna–de* is the prototype of present-day *hiragana*. In the highly sophisticated court culture of the Heian period (894–1192), Chinese callligraphy and literature were regarded as male preserves. At first, aristocratic women were not encouraged to learn calligraphy, but some started to use *kana* to express themselves in poems and letters. Many of these artworks were created on papers richly

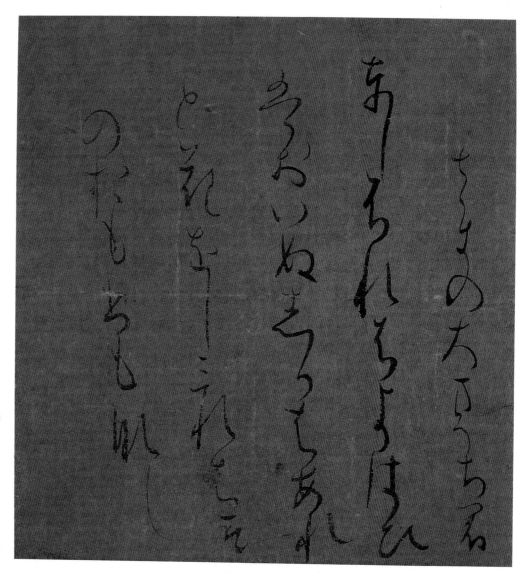

Right: *Sun Sho An Shikishi*, attributed to Ki No Tsurayuki—a fine example of rhythmically flowing *kana*.

Left: *Masu Shikishi* attributed to Fujiwara No Yukinari—a beautiful example of *kana*'s elegant flow.

Bottom: *Genei Bon Kokinwaka Shu* (1120) attributed to Fujiwara Sadazane. The work was done on richly decorated paper.

decorated with gold and silver leaf, with exquisite inlaid patterning. As calligraphy grew in popularity, many women became as well educated as the male politicians at court. This period saw some of Japan's finest literary masterpieces created by women, including Lady Murasaki Shikibu's romantic saga *The Tale of Genji*, a psychological study of love that is considered by many people to be the world's first novel. Seisho Nagon's sensual and witty anthology of court life, *The Pillow Book*, is part of a school of autobiographical Heian women's literature that is still widely read in Japan today.

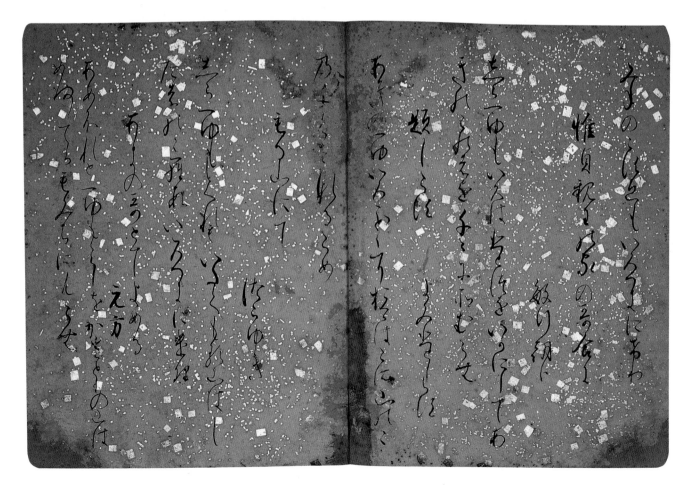

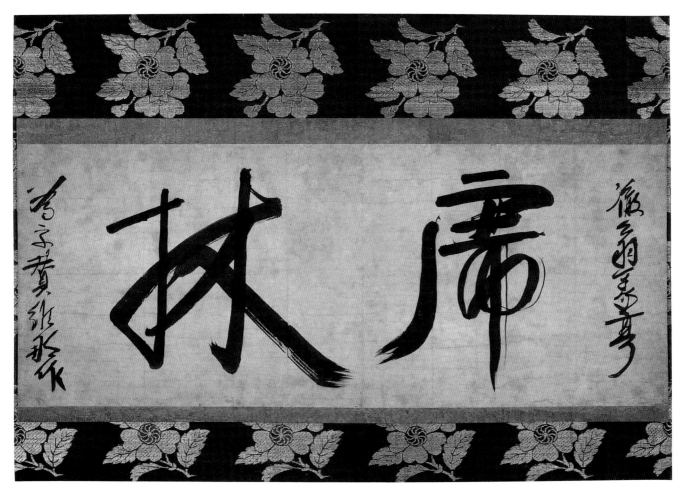

Above: *Kurin Jigo*, written in the 14th century by the Zen priest Tetto Giko. The spiritual strength is expressed through the elegance and gentle flow of the strokes.

The eleventh century provided Japan with a golden age of literature. It is also seen by many as the time when Japanese culture found its identity. With many of the best-known works created by women, the Heian period still influences art, calligraphy, and aesthetics today. In calligraphy, *kana* writing has kept the cultivated elegance it developed in the literature of this time. Noblemen became so fascinated by the elegant style in which these books were written that when the *Kokin Waka Shu*, the first poetic anthology selected by the Emperor, was compiled around 910, it was written in *onna-de kana*, even though more than 100 of the 127 poets featured were men. Nostalgia for the art of the Heian period has been a characteristic of Japanese culture for many centuries.

In 1192 the Heian period ended and the Kamakura period (1192–1333), which saw the beginning of the rule of the warlord samurai, began. As Japan became more unstable, people searched for new religious meaning, and many new Buddhist sects were established at this time. Zen Buddhist monks produced a clean, strong writing style, named *boku seki*, which incorporated the latest fashions from Sung- and Yuan-dynasty China.

Above: A letter written around 1590 by the Zen follower and merchant Sen No Rikyu. He developed *sado*—the way of tea—and the *wabi cha*, where the simple and subdued way of serving and enjoying tea is appreciated. This letter shows his spirit. In tea ceremony rooms a scroll with calligraphy work is often admired.

Right: A *tanzaku*, or tablet, by Matsuo Basho who established the *haiku*—a short poem consisting of 17 syllables. *Haiku's*

The sixteenth and seventeenth centuries saw a vibrant development of the Japanese economy, which promoted the spread of the arts. Originally an interest only of the imperial or aristocratic classes, cultural pursuits became popular among the samurai and merchant classes. The tea ceremony (*sado*), developed from its medieval Buddhist beginnings by a merchant and Zen follower Sen No Rikyu, was much practiced. As calligraphy spread out of the court, poets and tea-ceremony masters started to show their unique talent. Reinventing the tea ceremony as a ritual of humility, simplicity, and self-cultivation strongly influenced by Zen teaching, Sen No Rikyu introduced a calligraphy scroll or drawing as part of the ceremony, to be hung in the alcove of the tea room to welcome guests. Sen No Rikyu appreciated calligraphy more than any other form of decoration, so many calligraphy works, especially early *kana* works, were cut into strips and arranged as hangings in the alcove.

In the seventeenth century, Matsuo Basho established a new form of poetry, the *haiku*, which aims to express the most complex human emotions with wit and insight, using only 17 syllables. Basho's way of expressing deep emotions in a light way reflects his pursuit of spiritual profundity.

In the eighteenth and nineteenth centuries, Zen Buddhist priests dominated calligraphy. In the mid-seventeenth century, much of the Buddhist Huangbo (Obaku) sect had arrived from China. Many Obaku monks were poets, painters, and calligraphers, and it was their influence that led to the rise of *zenga* (zen painting). *Zenga* describes the enlightenment of Zen in a simple painting, usually in black ink. Works by Hakuin Ekaku (1685–1768) are dynamic and bold, and promote Zen teachings. Sengai Gibou (1751–1839) left probably the

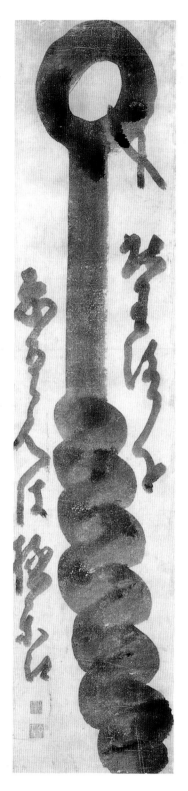

Left: Iron stick by Hakuin Ekaku, a priest known for his efforts to spread the teaching of Zen through simple and dynamic drawings and words. It says, "Those who are afraid of this thing will go to heaven."

most original *zenga*. His delightful, whimsical mix of humor is typical.

Today, Japanese calligraphy has diversified through *kana*, *kanji*, and *chowa-tai*—a harmonious style of writing modern poems with *kanji* and *kana* mixed. This rich variety reflects the history of Japanese calligraphy: cultural influences have constantly been imported and assimilated to create something new and unique. The best way to learn the secrets of calligraphy is to study the masterpieces, in which we can see the secret skills of brushwork and gain an insight into the minds of the masters who created them.

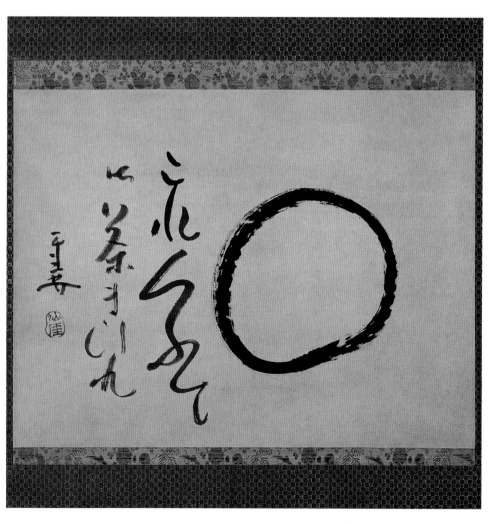

Right: *Enso*, or the Circle of Infinity, by Sengai Gibon, a Zen priest whose works are known for their comic vibrancy. The calligraphy reads, "Why not have a cup of tea with this as a sweet dumpling?"

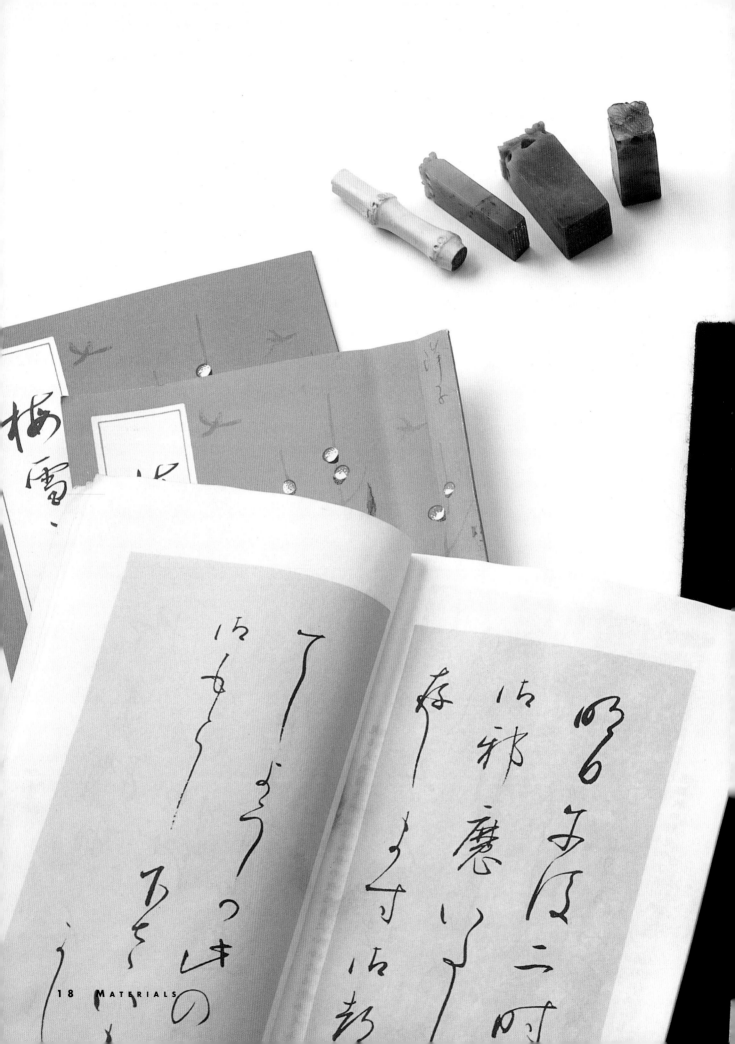

MATERIALS

The Four Treasures

The brush, ink, ink stone, and paper are regarded as the "Four Treasures" of calligraphy. Originating in China, where many are still made today, the materials have been cherished by calligraphers for many centuries. Some are now produced in Japan as well, and with technological advancement, the variety from which to choose has widened tremendously. As we place the treasures in their set positions and prepare to work, each helps our mind become calm in readiness for undertaking the art of calligraphy. Both Chinese and Japanese papers are appropriate according to the kind of work you are doing. If you work mainly with *kanji* (Chinese characters), use any sort of Chinese *xuan* writing paper, known as *senshi* in Japanese. This absorbent paper lets the ink spread more across the surface. When working in *kana* (Japanese writing systems), use Japanese *washi*—grass paper made with the longer fibers of such plants as kozo, paper mulberry, and mitsumata, which are all unique to Japan. Some paper is coated so that the ink will not spread too much across it.

Paper—Senshi and Washi

Japanese Papers

Known as *washi*, these papers come in a multitude of shapes and sizes. Far left: Large-sized paper matures and becomes easier to work on as it ages. Left: *Chiyogami* is stamped with patterns and foil.

Practice Paper

Specially made for practice pieces, this paper is absorbent and easy to use. You can also use it for calligraphy, and then paste the paper onto non-absorbent materials for practical work.

Grass Paper

Below: Grass paper is made from the paper mulberry tree, and the mitsumata or *edgeworthia papyrifera* trees, both unique to Japan. Many grass papers are coated to stop ink bleed on the paper.

Choosing Paper

Choose from Chinese and Japanese
paper for your work. If your piece is
mainly in *kanji* (Chinese characters),
Chinese writing paper, known as *xuan*,
or *senshi* in Japanese, is the best
choice. For a mainly *kana* artwork,
use "grass paper" with longer fibers.

Handmade Paper

Right: Textured handmade paper
strips are studded with leaves,
plant stems and flower petals.
Far right: Long paper "tablets"
are used for calligraphy
with *haiku*.

Ink—Sumi

Traditionally, ink (*sumi* in Japanese) is produced in solid sticks made by combining soot, glue, and water. The type of soot defines the ink. Sticks made with the soot from the natural oil of rape seed, *paulownia*, or sesame are named *yu en boku* ("oil smoke ink"). The soot particles are regular and small in size. This type of ink gives a warm black, and when diluted with water, it gives a brown shade. Ink sticks made from pine soot are called *sho en boku* ("pine smoke ink"). Gathering soot by burning resinous pine is hard work, so recently a chemical alternative has been developed. In either case, the soot particles are irregular and larger in size. This ink makes a cooler color, and when diluted with water, it turns a purplish shade. There is no strict rule as to which type of ink is used for any particular type of work, but through practice you'll find which inks and shades you prefer.

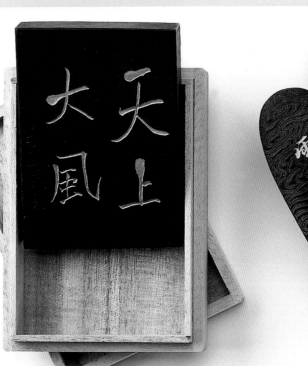

Chinese pine stick inscribed "Cloud liquid"

Japanese oil-soot ink stick with calligraphy: "In Heaven a huge wind is blowing."

Oil-soot ink stick

Shades of oil-soot ink

Pine-soot ink stick

Shades of pine-soot ink

It is said that ink gets better as it grows older. This is because when the ink is made it contains more glue than is needed when writing. After three to five years, some of that glue has disappeared and the composition is close to ideal. Some calligraphers maintain that ten-year-old ink sticks are better, while thirty- to sixty-year-old inks may be at their prime. Some good ink sticks have lasted more than a hundred years.

Ink behaves like a living creature to the artist: its real effect cannot be appreciated until it is applied to paper. Experiment and study other calligraphers' works for the depth and shades of the ink used.

Ready-mixed liquid inks are also available: these can be handy when you don't have time to prepare your own ink. Although there is no stigma in using ready-mixed ink, never forget that while you are rubbing your ink stick on your ink stone, you are not wasting time. Rather, you are taking a few moments to achieve the calmness necessary for fine calligraphy.

Some ink sticks are ornamented with fabulous decorations and some are so ornate that they are created solely as collectors' items. For practical use, plain ink sticks are fine.

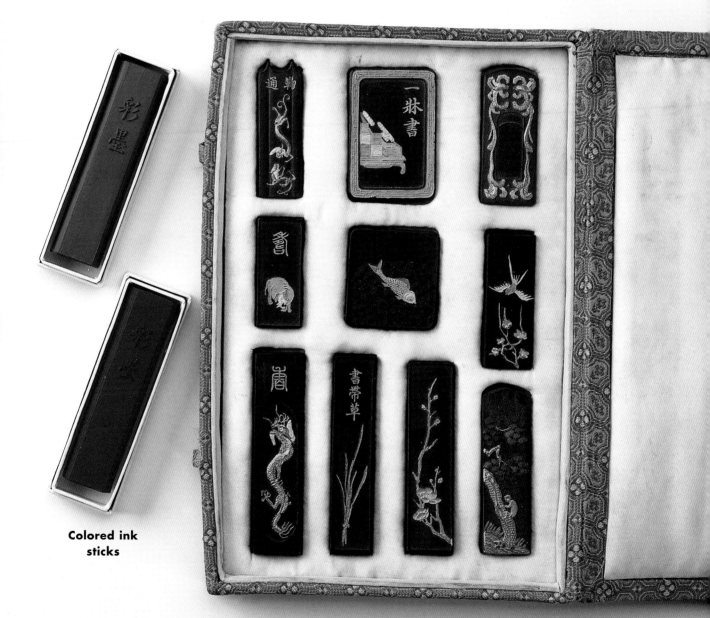

Colored ink sticks

Chinese antique, pine-soot ink sticks—collected as artefacts by calligraphers

BRUSHES—FUDE

The brush (known as *fude* in Japanese) is a very important tool in calligraphy: as the vehicle of the artist's soul, all the artist's expression depends on the control of its tip. Therefore, today, just as the ninth-century calligraphy saint Kukai wrote, "It is very important to choose a good brush." However, you do not have to start with an expensive brush. Choose an ordinary one, take good care of it every time you use it, and you will feel more and more comfortable with it at every calligraphy session.

Brushes are made from a wide variety of animal hairs, which fall into three basic categories: soft, such as goat; hard, such as weasel, rabbit, or horse; and a mixture of the two, with a hard core and a softer outside. There are also brushes with tips made from wood, bamboo, or grass, so if you are looking for some special effect, the variety is unlimited. Theoretically, you can make brushes with any animal hair as long as it has not been trimmed. Some artists do use brushes made with the hair of a new-born baby whose hair has never been cut. Selecting a brush is largely a matter of personal preference. Some professional artists use a single brush for all purposes, others use a variety.

For beginners, harder brushes may be easier to handle. Soft brushes are suitable for more cursive works and the brushes with stiff hair and a sharp tip are suitable for detailed work. With careful use, some brushes will last a lifetime.

Large, soft brush

Pine-branch brush

Large, soft brush for large *kanji* characters

Medium, soft brush

Medium, soft brush

Medium-small, hard brush for *kana* and *kanji* characters

How to care for a brush

When new, a brush tip is covered with water-soluble glue that keeps it in shape. Hold the brush in one hand and gently loosen the tip with the other. On a large brush, squeeze two-thirds of the way up from the tip, but on a small brush, work only a quarter of the way up. Remove the glue with a sponge; be careful to loosen the brush gradually so that the hairs are not damaged.

New brushes may come with a protective plastic cover. This should be discarded after purchase. Do not try to put it back over the tip once the glue has been removed from the brush.

After use, immediately clean your brushes in clean, cold water. For small brushes, use dampened paper or a sponge to protect the hairs. Let them dry thoroughly by hanging them from the small fabric loops at the top of the brush. Before placing brushes back in the pot, make sure they are completely dry. If you need to travel with your brushes, wrap them in a bamboo roll that will keep them safe and dry while you are traveling.

Small, standard *kana* brush for delicate work

Medium, standard brush for kanji

Small, hard *kana* brush

Small, hard *kana* brush

Small, soft *kana* brush

Small, hard *kana* brush

Small, hard/soft, mixed-hair *kana* brush

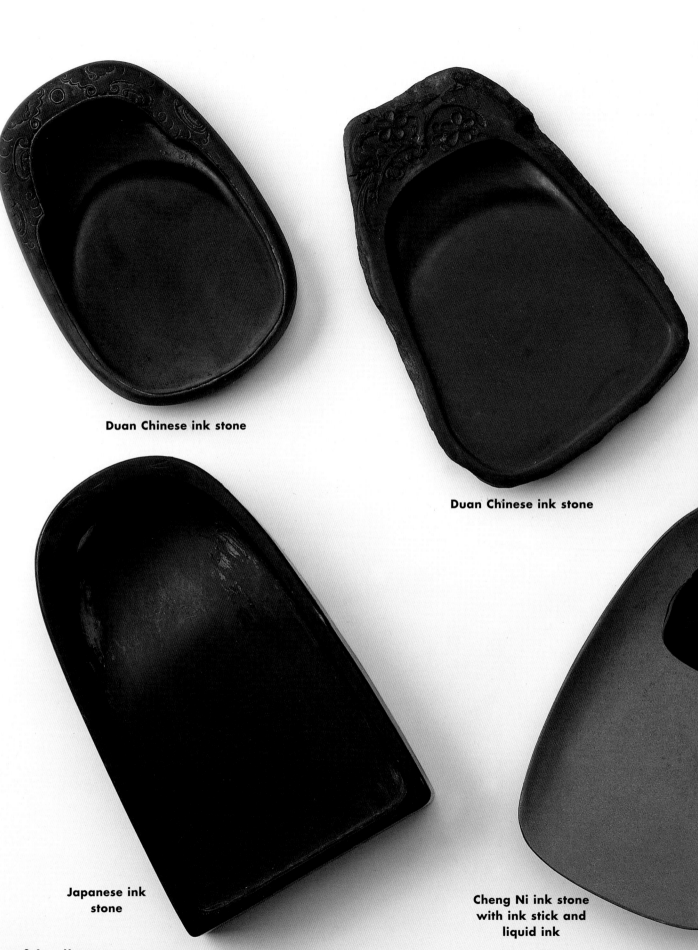

Duan Chinese ink stone

Duan Chinese ink stone

Japanese ink stone

Cheng Ni ink stone with ink stick and liquid ink

INK STONES—SUZURI

A good ink stone, or *suzuri*, has a surface that balances smoothness and solidity with the ability to produce ink quickly when an ink stick is ground against it. All depends on the stone from which it is made, and historically China is famous for very good ink stones such as the Duan (in Japanese, Tankei) and Cheng Ni (Chouden). Some Japanese manufacturers now produce good stones as well.

Ink stones can be of various shapes—square, round, or left as natural in the rock shape they are hewn from the earth. Today a wide variety is available, and even ceramic ink stones have been developed. Unglazed pottery can be a substitute for an ink stone, as long as it can grind the ink stick while not damaging the brush.

Some ink stones are beautiful as well as practical, with carvings of landscapes, gods, fantastical beasts, flowers, and even calligraphy. The surface of the stone is divided into two areas, known as the *oka* (land) and the *umi* (sea). The *oka* is the flat surface on which you rub your ink stick, while the *umi* is the surrounding furrow that holds the liquid ink. To mix ink, start by pouring a few drops of water into the *umi*. Tip a little water up into the *oka* and rub the ink stick into it. Then bring back the thick ink into the *umi*, mixing it gently to make it even. Keep repeating the process until you get the thickness of ink you need. Be careful not to pour in too much water. The ink should stay underneath the level of the *oka*.

Always wash and dry your ink stone after use as if you leave the unused ink in the ink stone, it will dry firm and stay permanently. The more you care for your ink stone, the dearer it will become to you. A *tanka*, a Japanese short syllabic poem, by Hiroshi Oi reads, "What a charming ink stone! While I'm enjoying the smoothness of it, spring is coming closer in the tranquility of the night."

Factory-made functional ink stone

PREPARING MATERIALS

Preparing the table is an essential part of the spirit of calligraphy; as you move each of the Four Treasures to its appointed place, meditate on the work to come.

Seals

Practice books

Begin by placing your paper on a felt mat and put a paper weight on top so that it will stay still while you are working on it with your brush. The lower part of the paper will be held in place by your left hand.

If you are right-handed, place your ink stone and brushes on your right, close to hand, as shown here. If you are left-handed, swap all your materials to the other side of the table.

When you are ready, start preparing the ink. Pour some water onto your ink stone using a water dropper and start grinding your ink stick gently, as if you are tracing an oval on the surface. When the ink starts to darken, push it into the furrow around the side of the ink stone, called the *umi* (see page 27), and pour more water onto the ink stone, repeating the process. Although liquid ink is now available ready-made, the grinding process is an important part of meditation before starting work.

The seals can be kept around you together with the seal ink and the gauge that helps you to seal the work properly.

Square gauge

Seal ink

Brush pot

Weighted paper

Ink stick

Water drop

Brushes and brush rest

Ink stone

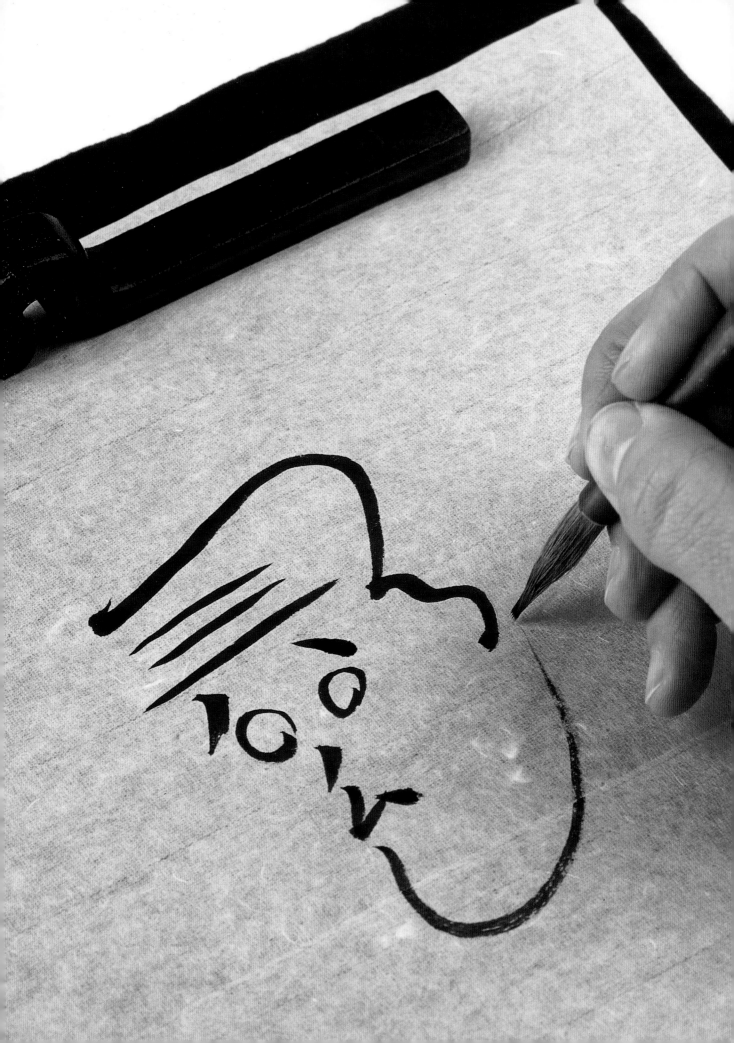

TECHNIQUES

The written Japanese language uses three sets of characters: *kanji* (Chinese characters), and native *hiragana* and *katakana*. *Kanji* were originally developed in China and imported to Japan around the first century, and are now read in an entirely Japanese way. *Hiragana* and *katakana* are both phonetic alphabets derived from *kanji*. *Hiragana* is a flowing, cursive script generally used for native words and words of Chinese origin not written in *kanji*. *Katakana* is a rigid, non-cursive form which can be used in place of *hiragana*, but is often used for names, words, and greetings from other languages.

The art of Japanese calligraphy mixes *kanji* and all forms of *kana* for complete flexibility and creativity. This chapter shows you how to create *kanji* and all the *hiragana* and *katakana* in use today, along with some of the antique, elegant *sogana* alphabet. As well as demonstrating how to master the brush and the stroke techniques of every script, simple exercises are included throughout to enable you to create many beautiful words and phrases.

HOLDING THE BRUSH

Although the Japanese traditionally work sitting on the floor, it is entirely acceptable to create calligraphy at a table while sitting in a chair, provided you keep the right posture. Keep your back straight and your shoulders relaxed, put your feet firmly on the floor, and always keep a hand width's space between your stomach and the table.

How to Hold the Brush

There are two methods of holding the brush. In both, the brush is held with three fingers—the thumb, index finger, and middle finger—with most of the effort being made by the thumb and the index finger. Usually hold your brush at about one third from the bottom. However, if you are working on a large-scale work, hold it higher up the shaft. Keep a little space (about a hand's width) between your arm and the table so that your brush can move smoothly. To allow broader movements, never place your elbow on the table. For smaller-scale work, see opposite.

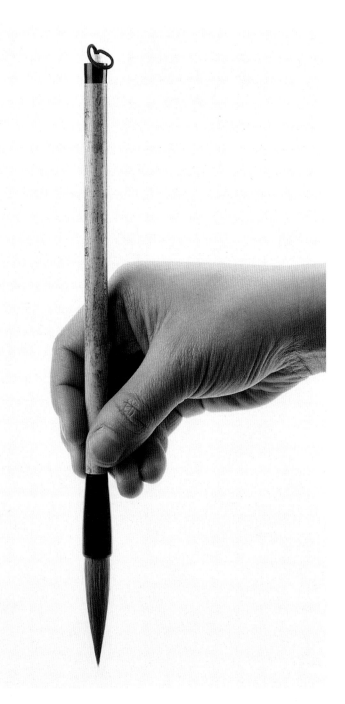

Method 1

In Method 1, as seen here, the brush is held on the same side as the index finger (*sokoho* in Japanese). Note that the ring finger and the little finger accompany the middle finger to retain the balance. Keep the brush vertical to the paper at all times.

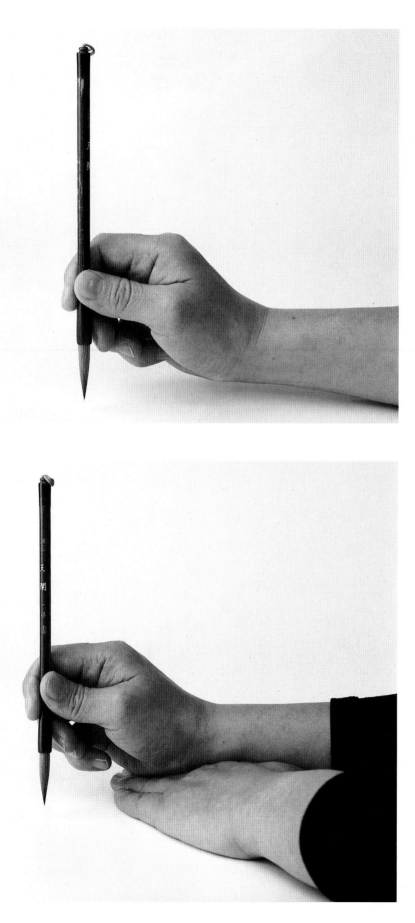

Method 2

As seen here, Method 2, the brush is held behind the index finger (*tankoho*). Note that here, too, the ring finger and the little finger accompany the middle finger to retain the balance you need for writing. Keep the brush vertical to the paper. To make it easy, simply hold your brush as you would a pencil.

Brush Control

When you are working on smaller pieces, and using small brushes, rest your elbow on the table in order to have better control of the tip of the brush, as seen above in Method 2. You can put your other hand underneath just like a pillow if you feel more comfortable (left.)

KANJI: DEVELOPMENT OF CHARACTERS

Chinese characters have a history dating back 3,000 years. From pictographic beginnings—where one character represents an object or concept visually—we have moved through a series of scripts to the forms of today. *Tensho* (seal) style clearly shows how elements are depicted; rain, for example, is described with dots that mimic the way in which raindrops fall. Although all styles shown here are still used in calligraphy, in the following pages we will learn to write *kaisho* and *gyosho*.

	TENSHO (Seal)	REISHO (Script style)	KAISHO (Block/Standard)	GYOSHO (Semi-cursive)	SOSHO (Cursive)
SUN	日	日	日	日	日
MOON	月	月	月	月	月
WATER	水	水	水	水	水
FIRE	火	火	火	火	火
WIND	風	風	風	風	風

TENSHO (Seal)	REISHO (Script style)	KAISHO (Block/Standard)	GYOSHO (Semi-cursive)	SOSHO (Cursive)

RAIN

EARTH

HEART

WOMAN

MOTHER

CHILD

MUSIC/FUN

Kanji Strokes: Kaisho

This exercise, *ei ji happou* (which means "training for basic strokes"), shows you how to master *kanji* strokes using *ei*, the Chinese character for eternity. This character includes most, if not all, of the classical strokes of *kanji* in *kaisho* (standard/block) script. When starting, use the practice grid as a template to place your strokes.

KAISHO (block) script

To learn the balance and composition of *kanji* characters, use a practice grid to help you position the individual strokes of calligraphy.

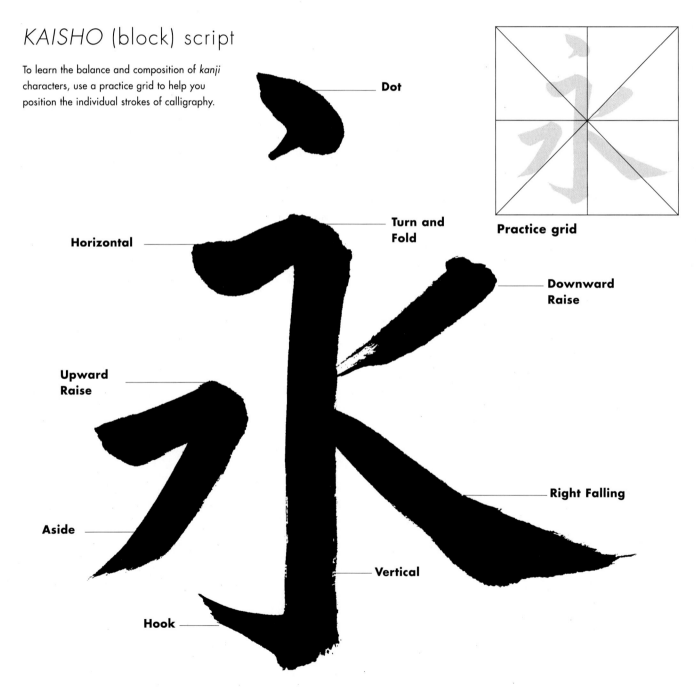

Dot

Turn and Fold

Horizontal

Downward Raise

Upward Raise

Aside

Right Falling

Vertical

Hook

Practice grid

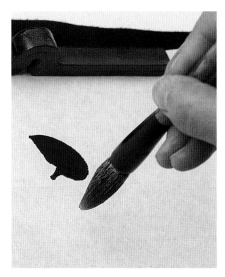

1st stroke: Dot

A dot, called *ten* in Japanese, is the beginning of everything. Not just a stroke in itself, the dot is also the start of other strokes. Hold your brush vertically over the paper, then pull it down at an angle of 45° while slightly turning the bottom of the brush toward you.

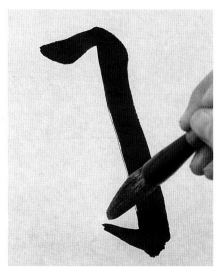

2nd stroke: Horizontal to Hook

This encompasses many techniques in just one stroke. First create a horizontal line. Start in the same way as you started the dot and move your brush with the tip running along the upper edge of the stroke. Bend your elbow away from your body and pull the brush sidewise, keeping the brush at a 90° angle to the paper and making sure that your line goes slightly up to the right. Then create the "turn and fold." Pull your brush up slightly so that you are ready to start a vertical line. Pull down your brush by moving the whole of your arm; the tip of your brush should run through the left side edge. At the end of the vertical line make a hook, always being aware in which direction you are going to make the hook: in this case, it goes toward the upper left at an angle of 45°. At the end of the vertical line, stop and turn the bottom of the brush toward the direction of the hook, and push forward. Lift the brush gradually away from the paper so that the hook makes a triangle.

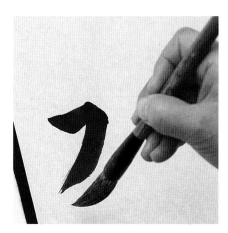

3rd stroke: Upward Raise and Aside

The upward raise begins in the same way as the horizontal, but with more upward pressure. Stop and turn the bottom of the brush to the lower left corner to make an aside, sweeping to the left. The tip of the brush should go along the upper edge. Lift the brush so that it produces a blade-like stroke.

4th Stroke: Downward Raise

Begin with a dot and take the brush tip toward your lower left. The brush tip should go along the upper edge. Lift your brush so that the stroke is shaped like a short blade.

5th Stroke: Right Falling

The right falling stroke runs from upper left to lower right at an angle of 45°. Widen the stroke as you make it by gradually pushing down the brush. At the base, turn the tip of your brush to the right while keeping the bottom fixed; move away and slightly up to the right to complete the stroke. Always keep your brush standing vertically up against the paper.

KANJI STROKES: GYOSHO

Gyosho (semi-cursive) style requires more movement and flow than *kaisho*. Historically, cursive or semi-cursive styles were developed before the block style. However, when you learn calligraphy it is easier to learn *kaisho* first to get used to the brush and ink and then go on to the semi-cursive or cursive styles. Some cursive styles are too deformed in variations and it is therefore difficult to make out what they mean. *Gyosho* is an easy-to-read, yet elegant, script.

GYOSHO
(semi-cursive) script

In most cases, you can form *gyosho* by following the same order as when writing *kaisho*. However, in some cases the order can differ, as is shown overleaf in the character for fall.

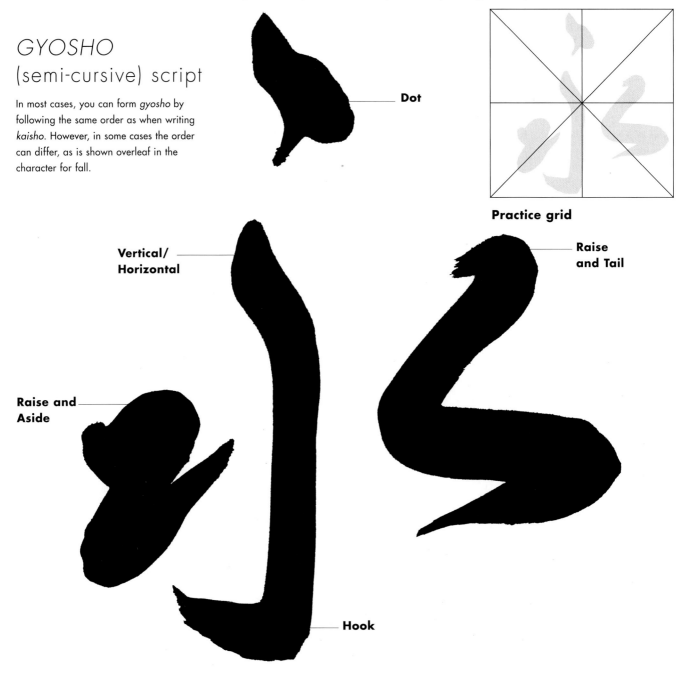

Dot

Practice grid

Vertical/ Horizontal

Raise and Tail

Raise and Aside

Hook

1st and 2nd strokes

Let's learn the basics of *gyosho* with by writing the character for eternity once more! As you can see in the vertical, *gyosho* is much more cursive. Also some simplification can be seen in the first horizontal before you make a turn.

3rd stroke

Note that the turn in *gyosho* is not acute—unlike *kaisho*. The direction of the aside has been changed to show the continuity to the next stroke. The movement of the brush is left visible from the left to the right.

4th and 5th strokes

Gyosho combines the 4th (downward raise) and 5th strokes of *kaisho* to form a single stroke.

The finish has also been changed. In *kaisho*, the final stroke went toward the right while in *gyosho* it comes back toward the left, indicating that the brush continues to write the next character.

KANJI: CREATING CHARACTERS

Here are the characters for the four seasons, four compass points, the "Four Beauties" (flower, bird, wind, and moon) and the phrase "Japanese calligraphy" with their stroke-by-stroke breakdown, showing the correct order in which to build up the balance and composition of each character. The *kaisho*, or block, form is the easiest to learn as each stroke of the characters is clear and crisp. The semi-cursive *gyosho* forms are also shown. With very few exceptions, the order in which to create *gyosho* characters is the same as that shown for *kaisho*.

KAISHO (Block/Standard)	ORDER	GYOSHO (Semi-cursive)

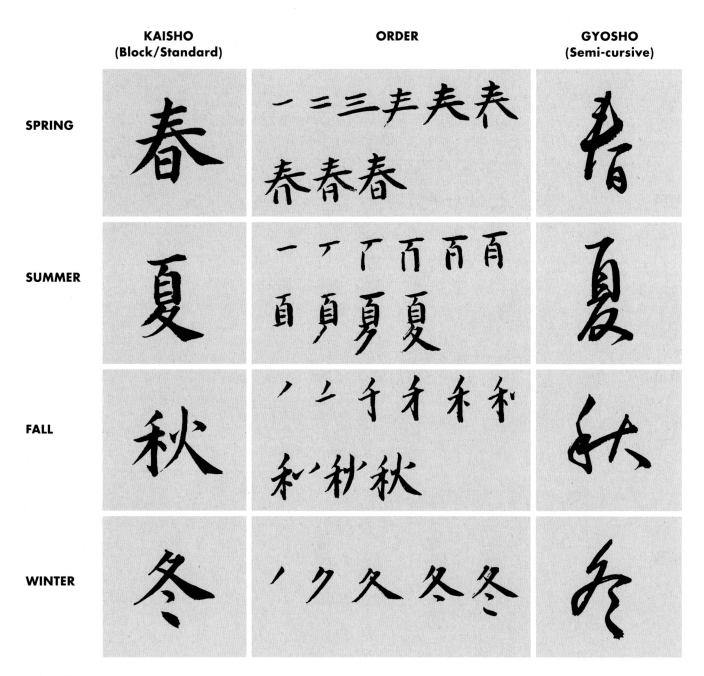

SPRING

SUMMER

FALL

WINTER

	KAISHO **(Block/Standard)**	**ORDER**	**GYOSHO** **(Semi-cursive)**
EAST	東	一 丆 戸 百 百 車 東 東	東
WEST	西	一 丆 両 西 西 西	西
SOUTH	南	一 十 广 宁 宁 南 南 南 南	南
NORTH	北	一 丬 北 北 北	北

	KAISHO (Block/Standard)	ORDER	GYOSHO (Semi-cursive)
FLOWER	花	一 十 艹 艹 芢 花	花
BIRD	鳥	⺊ 亻 竹 竹 自 自 鳥 鳥 鳥 鳥 鳥	鳥
WIND	風	丿 几 几 凡 凨 風 風 風 風	風
MOON	月	丿 刀 月 月	月

	KAISHO **(Block/Standard)**	**ORDER**	**GYOSHO** **(Semi-cursive)**

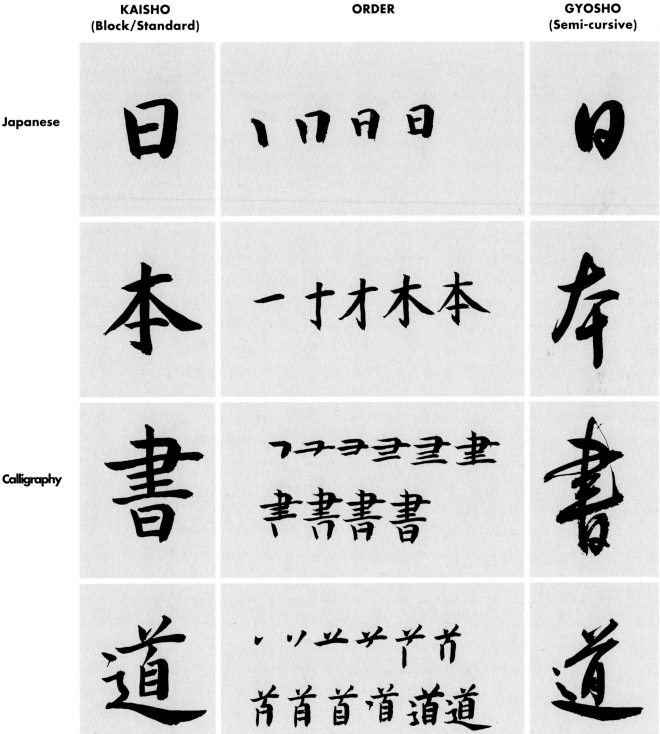

HIRAGANA: ALPHABET

The second set of Japanese characters in use today is a *kana*. *Hiragana* is a phonetic alphabet, but each character is derived from a particular Chinese *kanji*. There are 46 *hiragana* characters from which all the basic voiced sounds, basic combinations, and voiced combinations are made up.

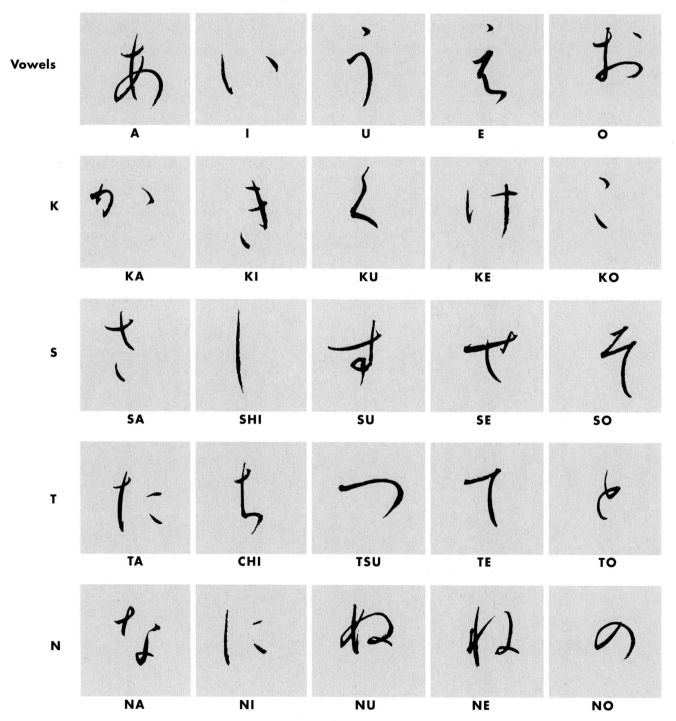

Vowels

A	I	U	E	O

K

KA	KI	KU	KE	KO

S

SA	SHI	SU	SE	SO

T

TA	CHI	TSU	TE	TO

N

NA	NI	NU	NE	NO

H は	ひ	ふ	へ	ほ
HA	**HI**	**FU**	**HE**	**HO**
M ま	み	む	め	も
MA	**MI**	**MU**	**ME**	**MO**
Y や		ゆ		よ
YA		**YU**		**YO**
R ら	り	つ	れ	ろ
RA	**RI**	**RU**	**RE**	**RO**

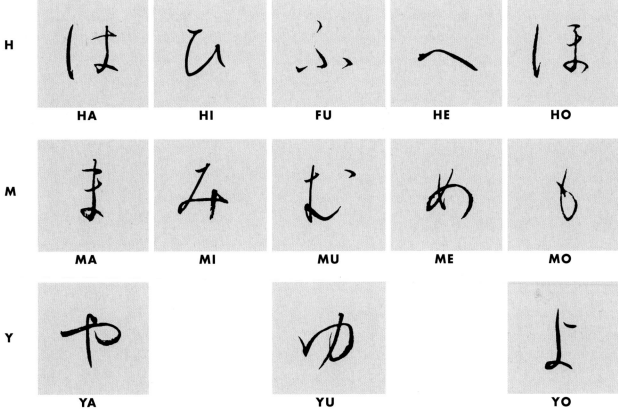

W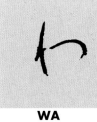

WA

を

WO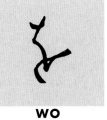

N ん

N

Basic Voiced Sounds

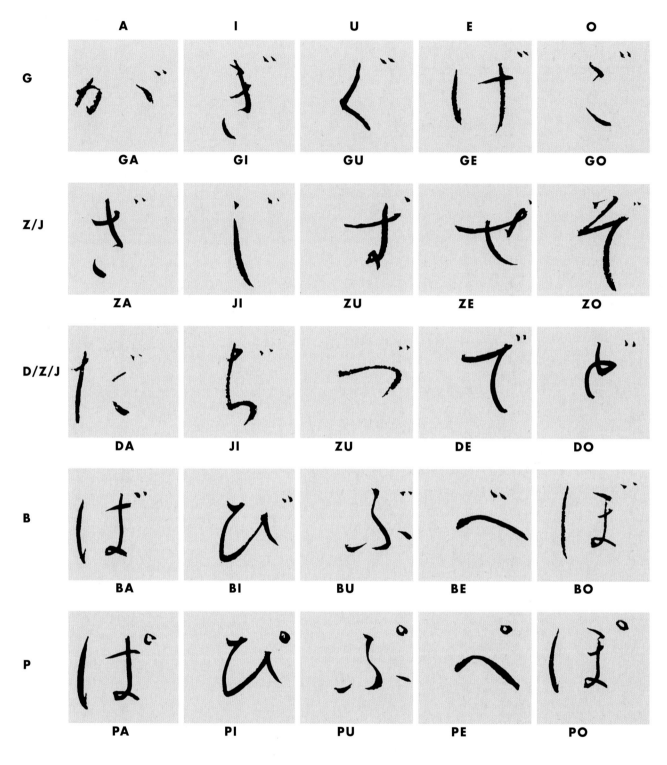

	A	**I**	**U**	**E**	**O**
G	GA	GI	GU	GE	GO
Z/J	ZA	JI	ZU	ZE	ZO
D/Z/J	DA	JI	ZU	DE	DO
B	BA	BI	BU	BE	BO
P	PA	PI	PU	PE	PO

Basic Combinations

	A	**U**	**O**
KY	KYA	KYU	KYO
SH	SHA	SHU	SHO
CH	CHA	CHU	CHO
NY	NYA	NYU	NYO
HY	HYA	HYU	HYO
MY	MYA	MYU	MYO
RY	RYA	RYU	RYO

Voiced Combinations

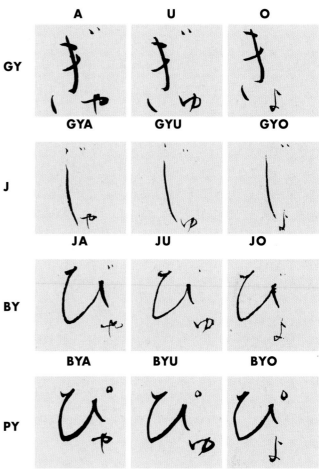

	A	**U**	**O**
GY	GYA	GYU	GYO
J	JA	JU	JO
BY	BYA	BYU	BYO
PY	PYA	PYU	PYO

HIRAGANA: STROKES

The main difference between *kanji*, shown on the left, and *hiragana*, shown on the right, is that *kanji* strokes are concave whereas *hiragana* strokes are convex. The top row here shows the difference in a horizontal stroke, while the second row shows the difference in a vertical stroke. In *kanji*, the beginning and ending of both horizontal and vertical strokes are fatter than the rest of the stroke. In the *hiragana* character, the beginning and the ending of the line are finer and lighter.

Kanji

Hiragana

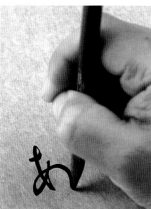
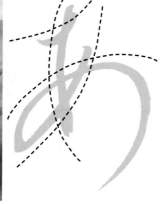

Arc Formation

Hiragana consists largely of flowing lines and arcs, which you should trace in the air with your brush as part of your mental preparation for making the stroke. The visible arcs, made only as strokes where the brush actually touches paper, may be only a small part of the whole—but this approach makes *hiragana* a round and gentle calligraphy style.

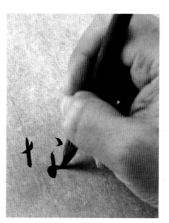

Square

A square line should not be rigid. In order to avoid making it too sharp, try to add a little bit of extra pressure just before you make a rightward turn, and reduce the pressure after turning.

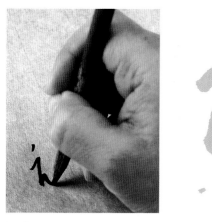

Sidewise Loop

When completing the loop from left to right, apply a little bit of extra pressure to the tip of the brush and relax the pressure as you finish the stroke. In this way, you can avoid making your loop uncontrollably huge. This technique can be used for other sidewise loops as well.

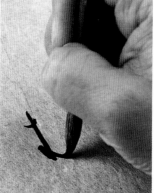
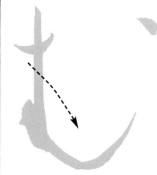

Vertical Loop

When making this loop in the middle of the stroke, first push upward and then push downward, "torturing the tip of the brush." Always keep your brush standing vertical against the surface. All strokes should be made exploiting the resilience or elasticity of the brush.

HIRAGANA: EXERCISES

Unique in its calligraphy technique, *kana* depends on its flow and delicacy for its success. The three *kana* exercises below reveal key techniques for achieving elegant calligraphy; once you have mastered convex lines and brush turns, move on to the popular Japanese "face" to advance your stroke control. Try the "face" on page 72 when you have mastered both *hiragana* and *katakana* techniques.

Exercise 1

Convex Lines

To make the beginning and the ending of your convex strokes as natural as possible, the brush should be moving a little before the tip actually touches the paper. It should continue to move in the same direction after the tip is lifted away.

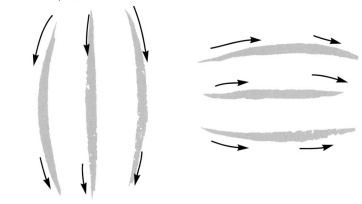

Exercise 2

Brush Turns

These four spring-like lines will allow you to practice making turns while writing *kana* characters. Always keep the brush vertical so that it can be turned sharply. The tip of the brush should be under pressure when you make a turn, so that the continuous line of *kana* gains rhythm.

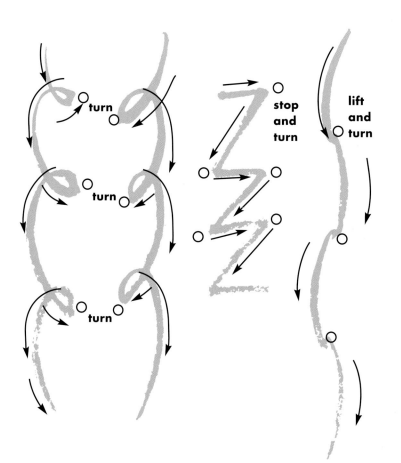

Exercise 3

Hiragana Face

This calligraphy exercise is popular in Japan—even as graffiti! Known as *he-no-he-no-mo-he-ji*, all parts of the face are made up of movements used when writing *hiragana*. Practicing the writing of the eyebrow (*he*), eye (*no*), eyebrow (*he*), eye (*no*), nose (*mo*), mouth (*he*), and face outline (*ji*), is a fun method of starting to learn how to flow characters together.

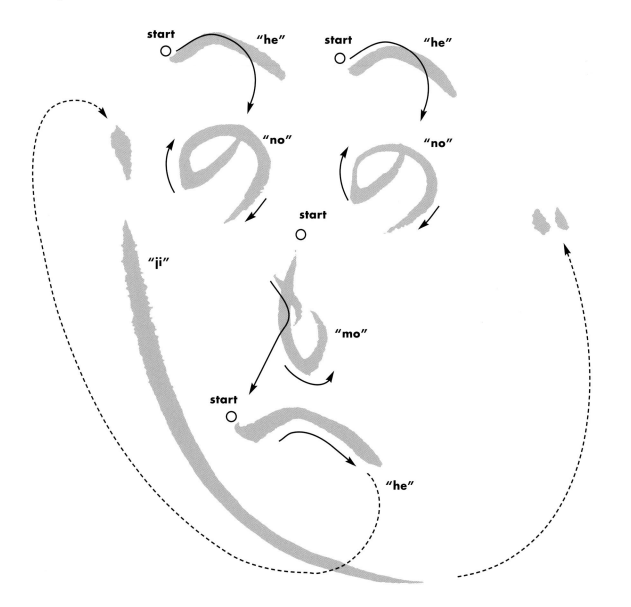

HIRAGANA: CREATING CHARACTERS

Hiragana characters consist of far fewer strokes than kanji. To keep the balance of the calligraphy, look at how each stroke is placed. The flow is also very important: each stroke moves in the direction in which it will continue. The strokes shown here are all convex, a characteristic of hiragana.

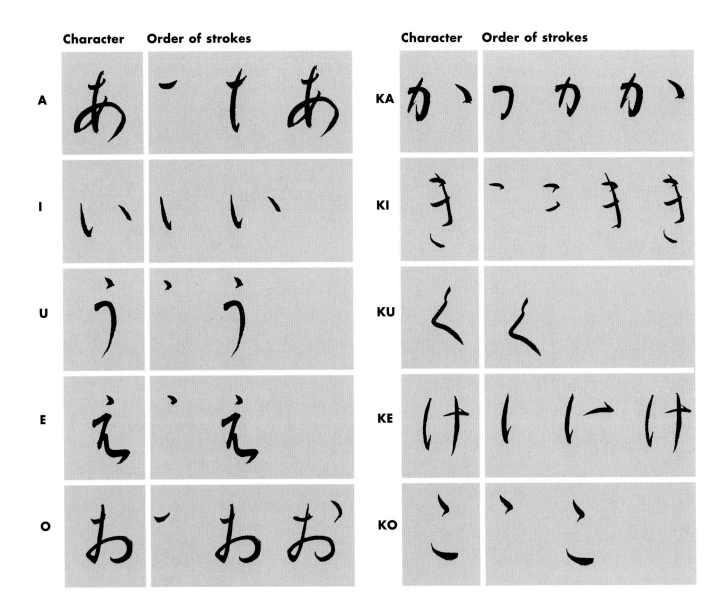

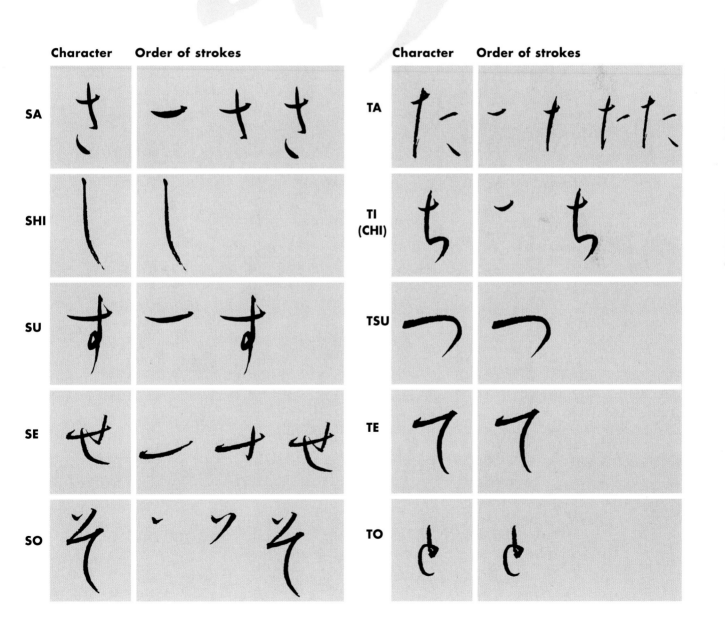

Character	Order of strokes		Character	Order of strokes
SA さ	ー さ さ	**TA** た	ー た た た	
SHI し	し	**TI (CHI)** ち	ち ち	
SU す	ー す	**TSU** つ	つ つ	
SE せ	ー せ せ	**TE** て	て	
SO そ	そ そ そ	**TO** と	と	

Character	Order of strokes		Character	Order of strokes
NA な	ー ナ な な	**HA** は	し し し は	
NI に	し し に	**HI** ひ	ひ ひ	
NU ぬ	し ぬ	**HU (FU)** ふ	ら ふ ふ	
NE ね	し ね	**HE** へ	へ	
NO の	の	**HO** ほ	し は ほ	

Character	Order of strokes			Character	Order of strokes		
MA まま	こ	こ	ま	**RA** ら	゙	ら	
MI み	み	み		**RI** り	り	り	
MU む	゙	も	む	**RU** る	る		
ME め	し	め		**RE** れ	れ	れ	れ
MO も	し	も		**RO** ろ	ろ		
YA や	っ	っ	や	**WA** わ	し	わ	
YU ゆ	ゆ	ゆ		**WO** を	゙	も	を
YO よ	゙	よ		**N** ん	ん		

RENMEN: FLOW OF KANA

Writing each *hiragana* character individually is called *hanachi-gaki*, which means "writing in separation." As you get used to using the tip of the brush, you will find that it becomes useful to be able to write more than one character in a line. This is known as *renmen*, which literally translates as "continuity." Although the rules are flexible, the most important factor is to keep a natural flow of the line. There are some useful tips that can help you when writing more than one character.

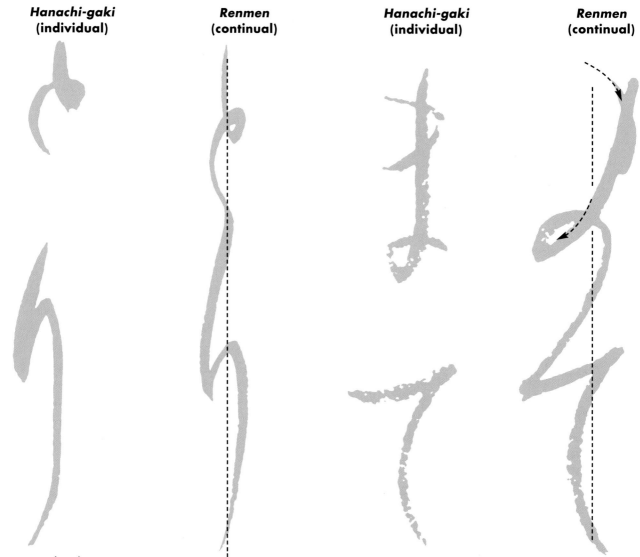

| **Hanachi-gaki (individual)** | **Renmen (continual)** | **Hanachi-gaki (individual)** | **Renmen (continual)** |

1) *To-ri*—bird
The end of *to* is in the middle of the line along with the beginning of *ri*. Join the two characters by continuing the second straight from the end of the first.

2) *Ma-te*—wait
This time, the end of *ma* is toward the right while *te* begins on the left. In order to avoid connecting them with a long sideline, turn the first character, *ma*, slightly sidewise so that it ends closer to the beginning point of the second character, *te*.

Hanachi-gaki (individual)	**Renmen** (continual)	**Hanachi-gaki** (individual)	**Renmen** (continual)

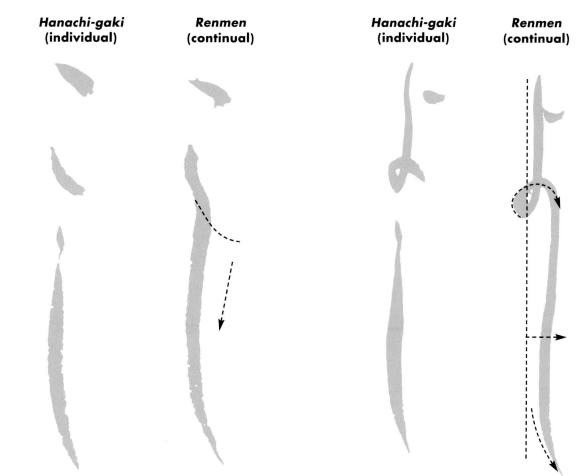

3) *Ko-shi*—go over

Use the same logic as with *ma-te* but instead of turning the first character sidewise, simply turn the last stroke of the first character down toward the second character (instead of up).

4) *Yo-shi*—good

When connected together, the sidewise loop of *yo* turns into an upward-facing, rounder loop before moving down to join up with the second character, *shi*.

5) *Ha-ru*—spring

As the first character, *ha*, ends toward the right, when the characters are connected together, the second character, *ru*, also begins from the right rather than in the center. A looping technique similar to that used in writing the *yo* character is also applied to *ha*.

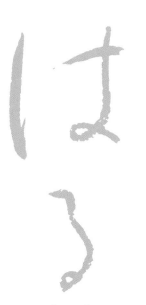

Hanachi-gaki (individual) **Renmen (continual)**

SOGANA

These Japanese phonetic characters have the cursive, scrolling style of Chinese *kanji*. Until the 19th century, when *kana* was simplified and standardized, many of these *sogana* were used in everyday life. Nowadays, they are used by calligraphers alone because of their grace and beauty. They can be used when you need to add accent to your *kana* work. Alternatively, when you want to create continuity (*renmen*), you can use them in place of *hiragana* characters. Here are 12 examples of the thousands of *sogana* used over the centuries; the three characters below left are direct ancestors of *hiragana*.

	Sogana	*Kanji*	*Hiragana*		*Sogana*	*Kanji*	*Hiragana*
WA	和	和	わ	NA		那	な
TE		天	て	NO		能	の
MO		毛	も	HA		者	は

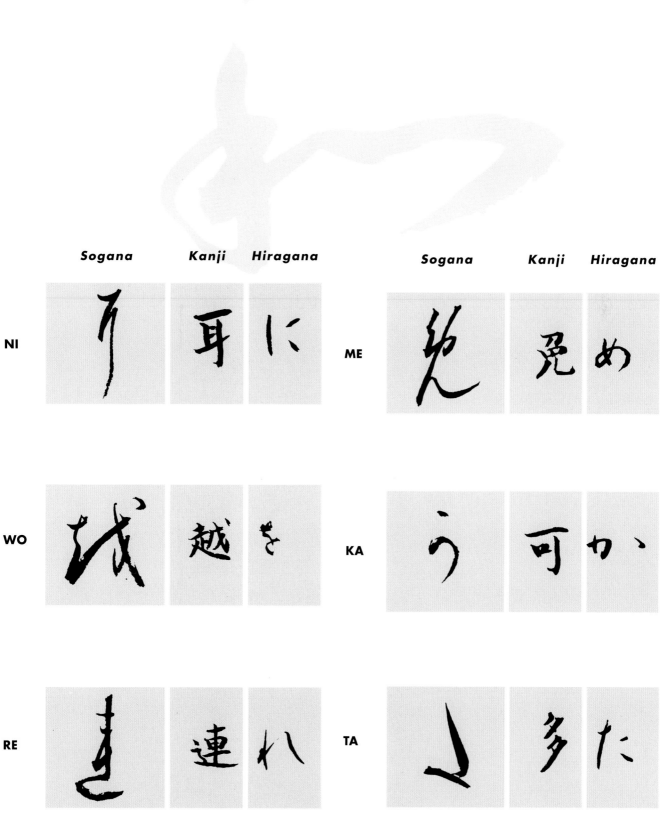

	Sogana	Kanji	Hiragana		Sogana	Kanji	Hiragana
NI		耳	に	ME		兒	め
WO		越	を	KA		可	か
RE		連	れ	TA		多	た

KATAKANA: ALPHABET

The third set of characters in use in Japan today is the 46-letter *katakana* alphabet. It is used for foreign names and words adopted from other cultures.

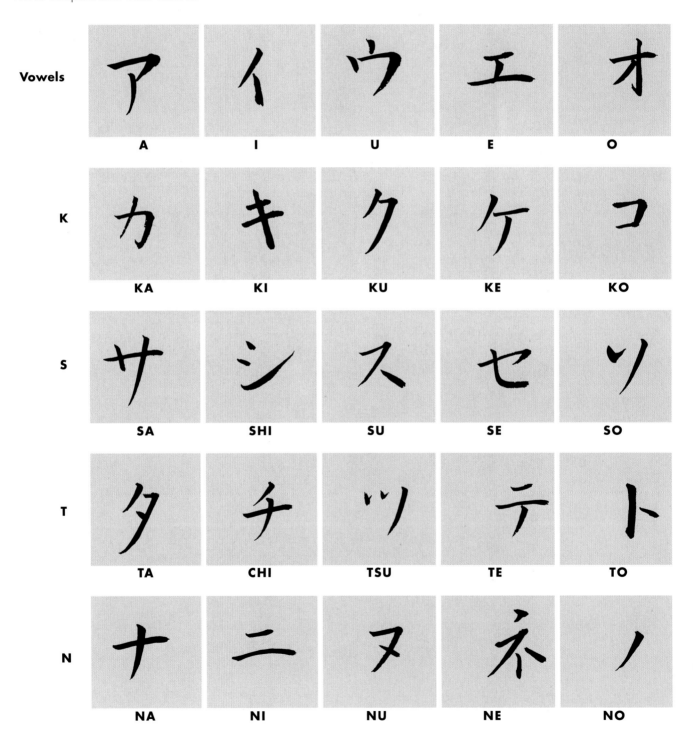

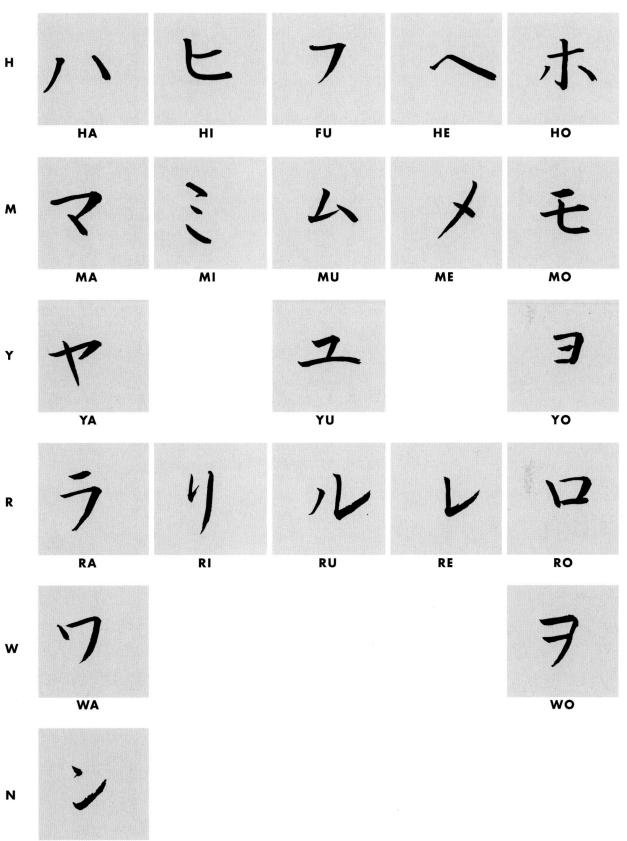

H ハ HA　ヒ HI　フ FU　ヘ HE　ホ HO

M マ MA　ミ MI　ム MU　メ ME　モ MO

Y ヤ YA　ユ YU　ヨ YO

R ラ RA　リ RI　ル RU　レ RE　ロ RO

W ワ WA　ヲ WO

N ン N

Basic Voiced Sounds

	A	I	U	E	O
G	ガ GA	ギ GI	グ GU	ゲ GE	ゴ GO
Z/J	ザ ZA	ジ JI	ズ ZU	ゼ ZE	ゾ ZO
D/Z/J	ダ DA	(ヂ) JI	ヅ ZU	デ DE	ド DO
B	バ BA	ビ BI	ブ BU	ベ BE	ボ BO
P	パ PA	ピ PI	プ PU	ペ PE	ポ PO

Basic Combinations

	A	**U**	**O**
KY	キャ KYA	キュ KYU	キョ KYO
SH	シャ SHA	シュ SHU	ショ SHO
CH	チャ CHA	チュ CHU	チョ CHO
NY	ニャ NYA	ニュ NYU	ニョ NYO
HY	ヒャ HYA	ヒュ HYU	ヒョ HYO
MY	ミャ MYA	ミュ MYU	ミョ MYO
RY	リャ RYA	リュ RYU	リョ RYO

Voiced Combinations

	A	**U**	**O**
GY	ギャ GYA	ギュ GYU	ギョ GYO
J	ジャ JA	ジュ JU	ジョ JO
BY	ビャ BYA	ビュ BYU	ビョ BYO
PY	ピャ PYA	ピュ PYU	ピョ PYO

KATAKANA: STROKES

Katakana consists of as few strokes as *hiragana*, but they are much sharper and crisper, just like block-style (*kaisho*) *kanji*. As you work, try to keep your brush almost vertical to the paper.

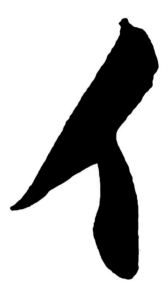

1st stroke—Dot

This stroke is identical to the *kanji* dot. Start the dot with the brush almost vertical to the paper and pull it slightly toward you to form a triangular shape.

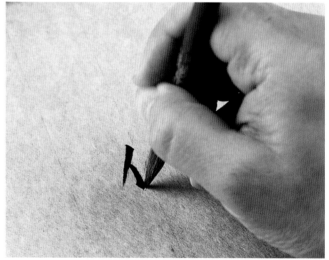

2nd stroke—Vertical

This stroke is identical to the *kanji* vertical line. Start the stroke with the brush almost vertical to the paper and pull the brush down. At the end of the stroke, push down the brush and pull it up slowly from the bottom, so that the tip is the last part of the brush to leave the paper.

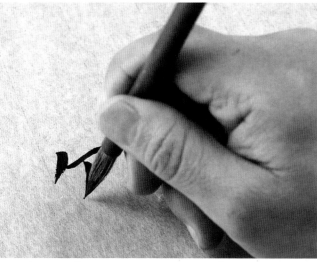

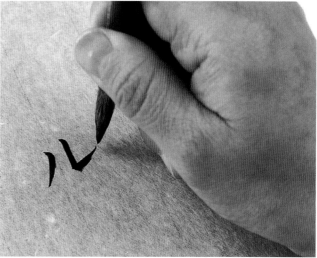

3rd stroke—Downward Raise

This stroke is identical to the *kanji* downward raise. Start the stroke with the brush almost vertical to the paper and pull it down toward the left. Gradually pull the brush away from the paper, letting the brush tip leave the paper last so that the end of the stroke forms a triangle.

4th stroke—Hook

This stroke starts like the *kanji* vertical and hook. Start the vertical with the brush almost vertical to the paper and pull it down. When you make a hook, push the brush up to the right to form a triangular shape.

KATAKANA: CREATING CHARACTERS

Katakana characters consist of far fewer strokes than their *kanji* ancestors. Each character is more rigid, similar to *kaisho*-style *kanji*, and the angles are acute. Use this script for foreign words, such as Christmas or Western-style greetings, as well as to represent Western names.

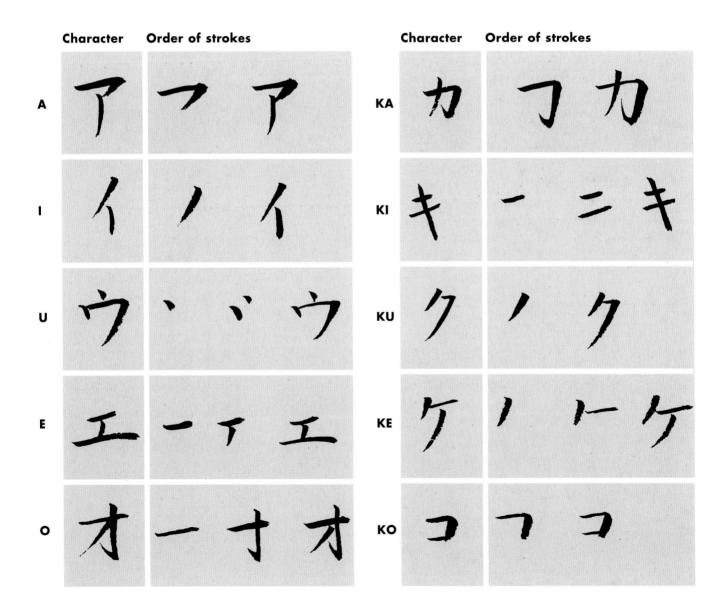

	Character	Order of strokes		Character	Order of strokes
A	ア	フ ア	KA	カ	フ カ
I	イ	ノ イ	KI	キ	ー ニ キ
U	ウ	` ゛ ウ	KU	ク	ノ ク
E	エ	ー ィ エ	KE	ケ	ノ ト ケ
O	オ	ー ナ オ	KO	コ	フ コ

Character	Order of strokes				Character	Order of strokes			
SA	サ	ー	ャ	サ	TA	タ	ノ	ク	タ
SHI	シ	ゝ	ニ	シ	TI (CHI)	チ	ノ	二	チ
SU	ス	フ	ス		TSU	ツ	ゝ	ゝゝ	ツ
SE	セ	つ	セ		TE	テ	ー	二	テ
SO	ソ	ゝ	ソ		TO	ト	l	ト	

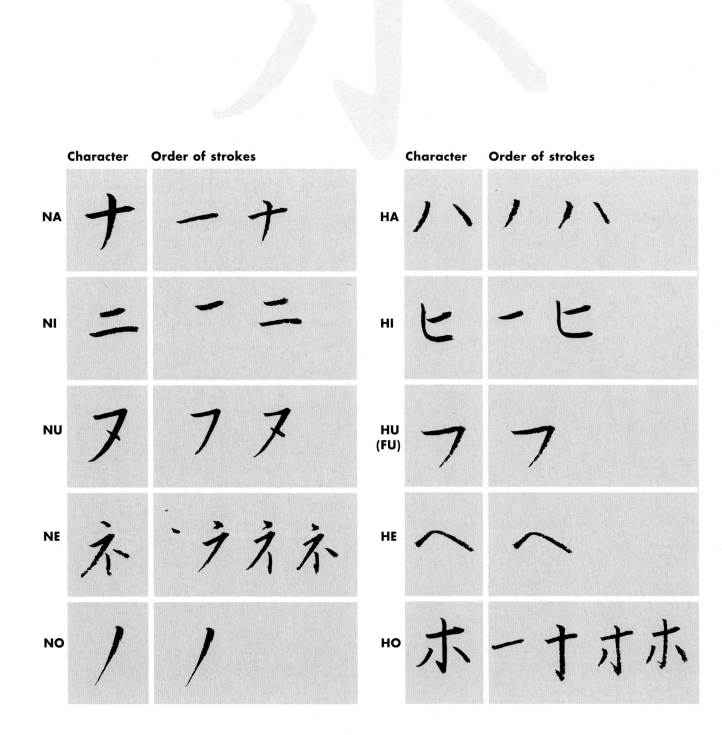

Character	Order of strokes		Character	Order of strokes
NA ナ	一 ナ		**HA** ハ	ノ ハ
NI ニ	一 ニ		**HI** ヒ	一 ヒ
NU ヌ	フ ヌ		**HU (FU)** フ	フ
NE ネ	` ラ ネ ネ		**HE** へ	へ
NO ノ	ノ		**HO** ホ	一 ナ オ ホ

Character	Order of strokes		Character	Order of strokes
MA マ	フ マ	**RA** ラ	ー ラ	
MI ミ	` ミ ミ	**RI** リ	レ リ	
MU ム	∠ ム	**RU** ル	ノ ル	
ME メ	ノ メ	**RE** レ	レ	
MO モ	ー ニ モ	**RO** ロ	l l ロ	
YA ヤ	フ ヤ	**WA** ワ	` ワ	
YU ユ	フ ユ	**WO** ヲ	ー ニ ヲ	
YO ヨ	フ ヲ ヨ	**N** ン	` ン	

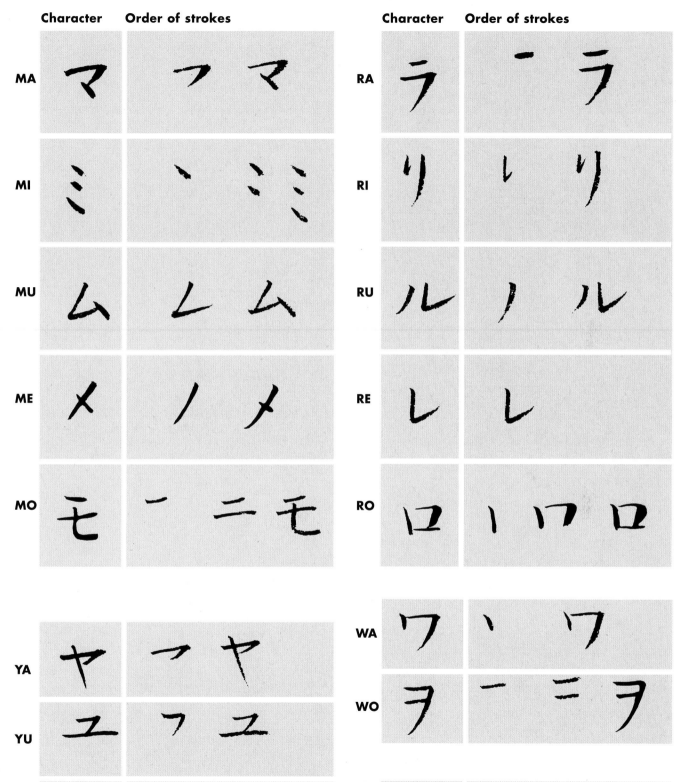

KATAKANA: CREATING COMPOSITIONS

These popular messages are all written in *katakana*, the phonetic symbols used to express foreign words. *Katakana* can be written either from left to right, or from top to bottom—though unlike *hiragana*, the characters are never joined together. Take care to keep your lines of characters even. When you practice writing from top to bottom, it can help to create a crease down the middle of the paper before you write so that you know where the center of each character should be.

FROM LEFT TO RIGHT

ハッピーニューイヤー

Happy New Year

ハッピーバレンタイン

Happy Valentine's Day

ハッピーハロウィーン

Happy Halloween

メリー クリスマス

Merry Christmas

グッドラック

Good Luck

FROM TOP TO BOTTOM

ハッピーニューイヤー

ハッピーバレンタイン

ハッピーハロウィーン

メリークリスマス

グッドラック

Happy New Year

Happy Valentine's Day

Happy Halloween

Merry Christmas

Good Luck

KANA: EXERCISE

Katakana technique has a great deal in common with *kanji* (block) style, as most *katakana* characters are made up of the same components, or part radicals, as *kanji*. Here, we are combining the spiky strokes of *katakana* with the flowing strokes of *hiragana* to create another "face."

Kana Exercise

This face combines both *hiragana* and *katakana* characters. As you practice, remember the different nature of the strokes used for each alphabet.

1 Start with the outline of the head (*tsu*) and ear (*ru*) in continuous *hiragana* (*renmen*).

2 The forehead (*san*), which translated literally means "three," is represented by three horizontal lines. Try to form a soft, willow-leaf shape. Form the eyebrow (*ha*) in *katakana*. Try to keep the shape sharp, with crisp stripes that form nicely trimmed eyebrows.

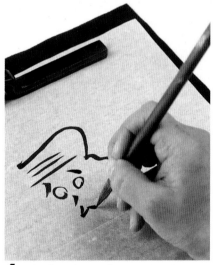

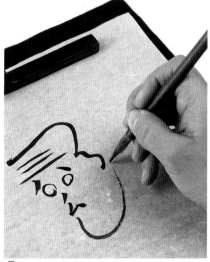

3 Translated literally, the word for eye (*maru*) means "circle." Try to shape round circles. Form one circle by moving clockwise, and the other by moving counterclockwise if you want to make a happier face. With *katakana*, create the nose (*no*). Shape it like a sharp, crisp blade from the upper right corner to the lower left.

4 Also form the mouth (*mu*) in *katakana*. Try to follow the gentle hook toward the upper right corner with a dot.

5 Revert to *hiragana* for the chin (*shi*). Try to shape a round and smooth line.

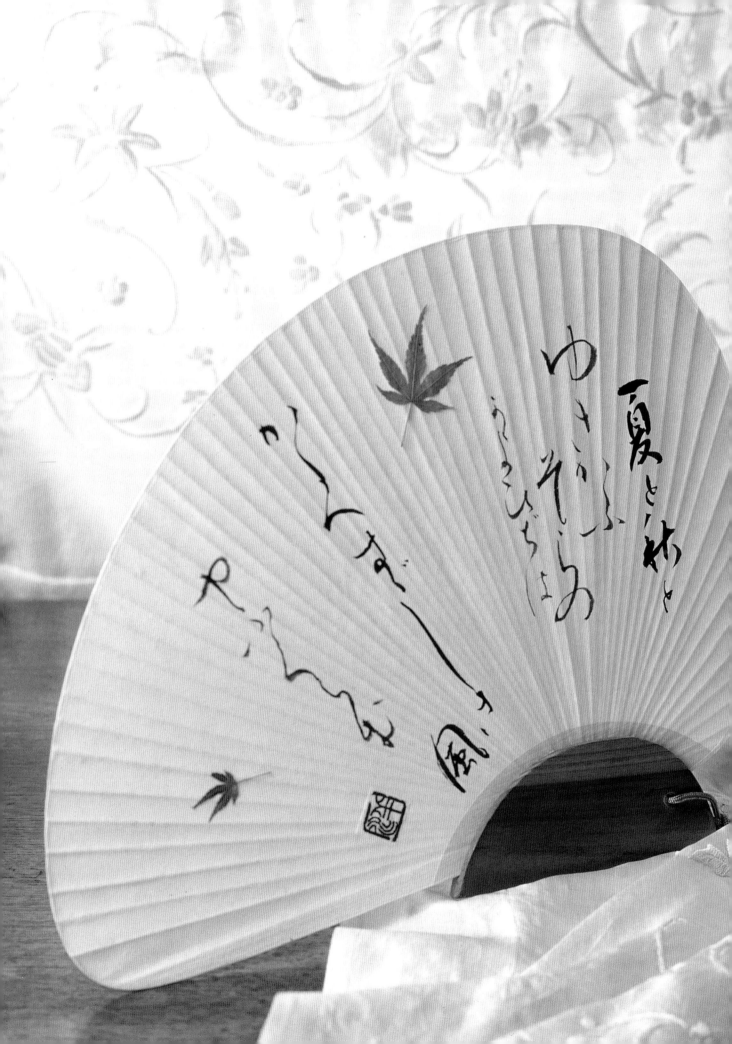

THE PROJECTS

Not just a spiritual practice for inner tranquility and harmony, Japanese calligraphy is an art that, according to tradition, should be used also to make our everyday lives more beautiful. The practical projects on the following pages contain many authentic uses of calligraphy for decoration on fabric, ceramics, and even rubber, with a special focus on creating artworks and objects using specially coated paper.

With the flexibility of this beautiful, colorful language at your fingertips, the possibilities of creating unique pieces are unlimited, while the calligraphy names section and haiku poetry from the Inspirations chapter allow you to personalize a gift with a special message.

GREETINGS CARDS

Especially in today's busy world, it can be hard to make a message for a special occasion truly personal. Traditionally the artform used in the East to convey both beauty and feeling, Japanese calligraphy is the ideal way to produce a unique artwork as well as a gift to be treasured. Combine the flowing elegance of the characters with matching origami decoration for a truly unique piece. Practiced for centuries in Japan as the foremost way to fulfillment, remember that, as you work through each of the following steps, you will be not only bringing happiness to the recipient but promoting your own inner harmony and creativity.

Paper Folding—Origami Crane

1 Fold a square piece of paper in half, corner to corner.

2 Fold in half again, this time along the longest straight edge.

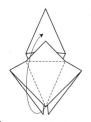

3 Reshape the topmost opening by pulling the top corner down to the bottom.

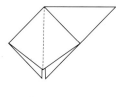

4 You are left with a diamond shape with a long point to the top right.

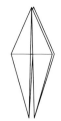 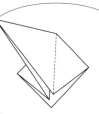

5 Turn the whole thing over and fold the long point across to the top right.

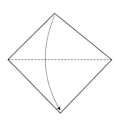

6 Placing your thumb inside the opening, reshape the flap, to leave a simple diamond shape.

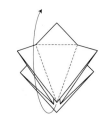

7 Making the creases as shown, fold the top flap up, allowing the topmost side flaps to meet in the center.

8 The side flaps should now be hidden. Turn the object over.

9 Again, make the creases as shown, and fold the top flap up allowing the side flaps to meet in the center.

10 You are left with a tall diamond-shaped object.

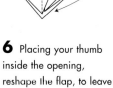

11 Make creases down each of the four long points and fold the flaps inward so that the outer edges meet at the center.

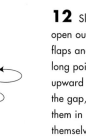

12 Slightly open out the side flaps and fold the long points upward through the gap, turning them in on themselves.

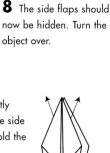 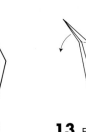 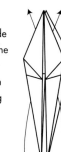

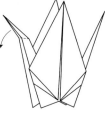

13 Fold down the top of one prong to form the head of the crane.

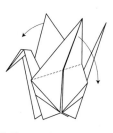

14 Fold down the wings.

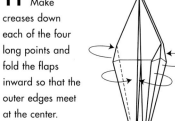

1 Start the first line at the top right, working downward in a straight line. Start by drawing a square clockwise, then create an S-shape to the right of the square. For the first *hiragana* character, *ke* (see page 52), keep the brush moving in a flowing downward sweep. Continue by writing a vertical, move right to create a horizontal, upward and left for the vertical stroke. To make up the *hiragana* character, *ma*, make two small horizontals then a snake-like stroke. Finally, write a long, straight vertical for the *hiragana*, *shi*, moving from left to right; end with an arc, for *te*.

2 Start the second line slightly below the first to the left, and place the third line further down still. Write the first *hiragana* character, *go*, as two horizontal dots, the bottom dot with greater emphasis, and two small, light dots on the further upper right corner. For the second and third *hiragana* characters, *za* and *i*, create a cross and a horizontal dot; then write a vertical with a further dot at the base left, with two more tiny dots in the upper right corner, and two short vertical strokes. For *ma*, a *hiragana* character transformed from the Chinese character, create a "roof" stroke. Finish with a cross and dot in the left lower corner for the final *hiragana* character *su*.

MATERIALS

4 greetings cards in watercolor paper,
6 x 5 in (15 x 12^1/$_2$ cm)
Writing brush
Black ink

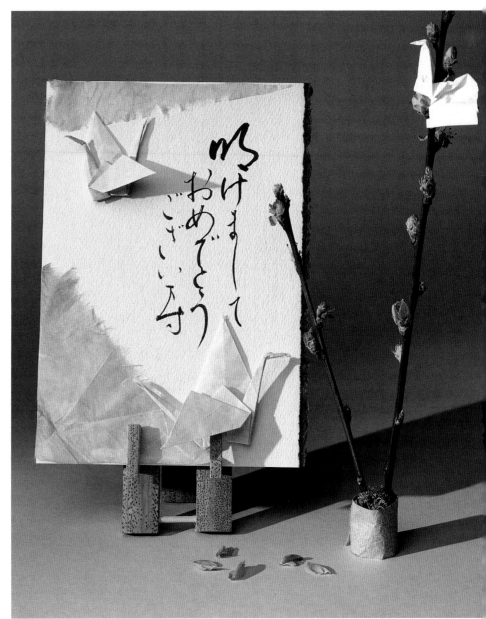

Happy New Year

A popular time of celebration in Japan, New Year often sees friends and families meet to exchange cards. As symbols of longevity and good fortune, tiny origami cranes fly upwards across the sky toward the New Year (see opposite).

Happy Birthday

Match birthday greetings to a traditional symbol of good luck, the golden carp. Good luck goldfish can be folded easily from a remnant of paper. The flow of water is added from torn crêpe paper.

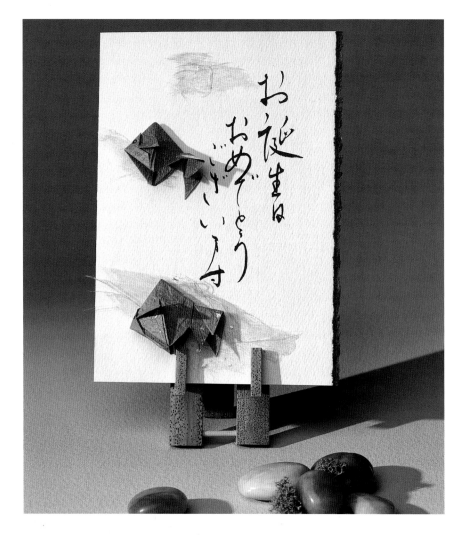

1 Create the first line, "birthday," as a single flowing stroke. Follow the shading of the brush, making the first character slightly lighter in tone, so that the focus falls on the second character.

2 Start the second line slightly below the first to the left. For the *ma* character, transformed from the Chinese character, create a "roof" stroke. Finish with a cross and dot in the left lower corner for the final *hiragana* character *su*.

Congratulations

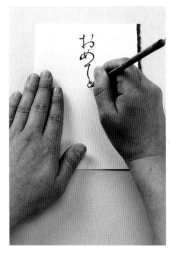

1 To create the first *hiragana* character, *o*, begin with a small horizontal followed by a vertical with a "knot" (see page 49). Draw the brush to the upper right, form a curve and finish with a dot above. Moving downward, write a cross, then, keeping a brush on the paper, pull the second diagonal round the page to create a hook, *me*.

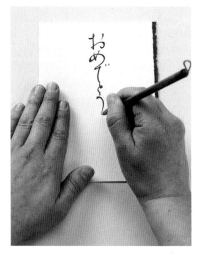

2 Start *de* with a horizontal stroke, and follow with an arc from the upper right to the left. Move down with a final, smooth vertical curve, and pull up the brush to make the two light, tiny dots in the upper right corner to create the character, *de*. Write a small knot for *te*, then finish with a smooth cursive line for the last character, *u*.

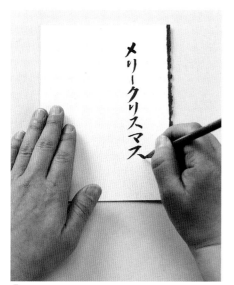

1 When creating the first line, make sure your strokes are sharp and crisp. Start at the upper right-hand corner with the first cross, moving to the bottom left, followed by a smaller stroke which goes from the upper left to the bottom righ for the character, *me*. Now draw two vertical lines; a short one to the left, then a longer one to the right, *ri*. Follow with a straight vertical, a small diagonal stroke from the right upper corner to the left bottom, followed by a hook (see page 37) with a longer slash, *ku* and *ri*. Create the triangle using the hook, and add a dot. Finish with a hook and a longer vertical with a short slash, and a small dot, *ma*.

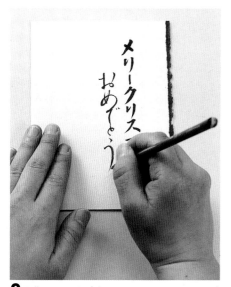

2 Follow step 2 of the "Happy New Year" card on page 77. Make the calligraphy flowing and cursive to provide a stylistic contrast to the graphic *katakana* line on its right.

Merry Christmas

The Japanese phrase for Christmas greetings, imported from the US, is created here in the energetic, graphic *katakana* script. Here, "Merry Christmas" sits to the right, with the congratulations message in the more flowing, looser *hiragana* style to the left. Using double-sided red-and-white paper, a simple origami creates a white-bearded Santa, with his accompanying holly in torn paper.

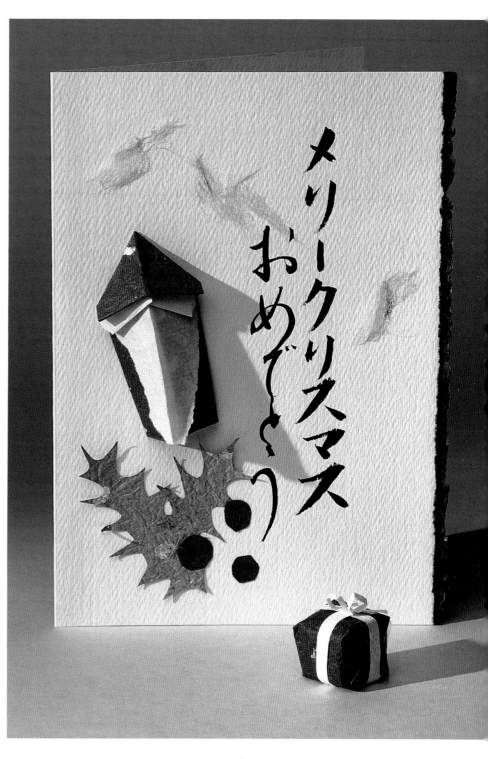

P O E M The characters on the Round Fan say:

The summer night is so short, The sun is rising while it is still night. Where in the clouds is the moon hiding itself?

As an alternative, try the fan on this section's opening pages which reads: *On the skyway, where summer and fall change places, cool wind must be running on one side.*

EVENING FAN

The heat of Japan ensured fans became popular as a means of keeping cool, and they are now also used for decoration. Writing on an uneven surface may seem daunting, but don't be afraid. When writing each line onto the fan, think about how it will look overall and position the characters to give the design balance. Vary the shades of ink in the strokes for interest.

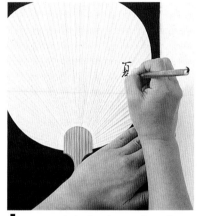

1 Begin with the first line on the right, working from top to bottom.

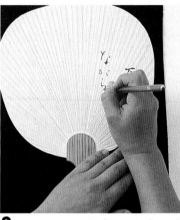

2 Continue across the fan, using less ink for the next line. When adding the ink to the brush, be careful not to put on too much. Keep some spare paper so that you can check the shade of the ink and wipe any excess off the brush if necessary.

MATERIALS

Fans
Small *kana* brush
Black ink

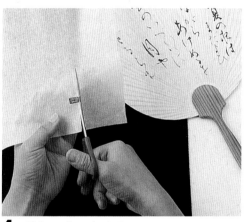

4 Add the seal. As the surface is uneven you may find it easier to make a seal on a separate sheet of paper.

3 Create highlights in your calligraphy by varying the density and the height of the characters. Here I have made the fifth line longer, but using less ink keeps it balanced.

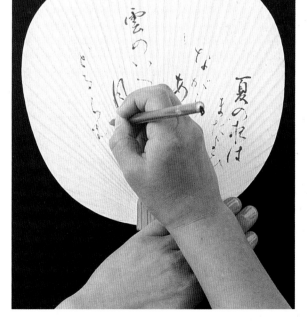

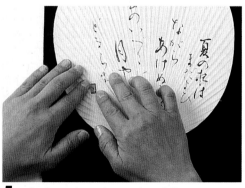

5 To finish, cut the seal out and carefully paste it onto the fan.

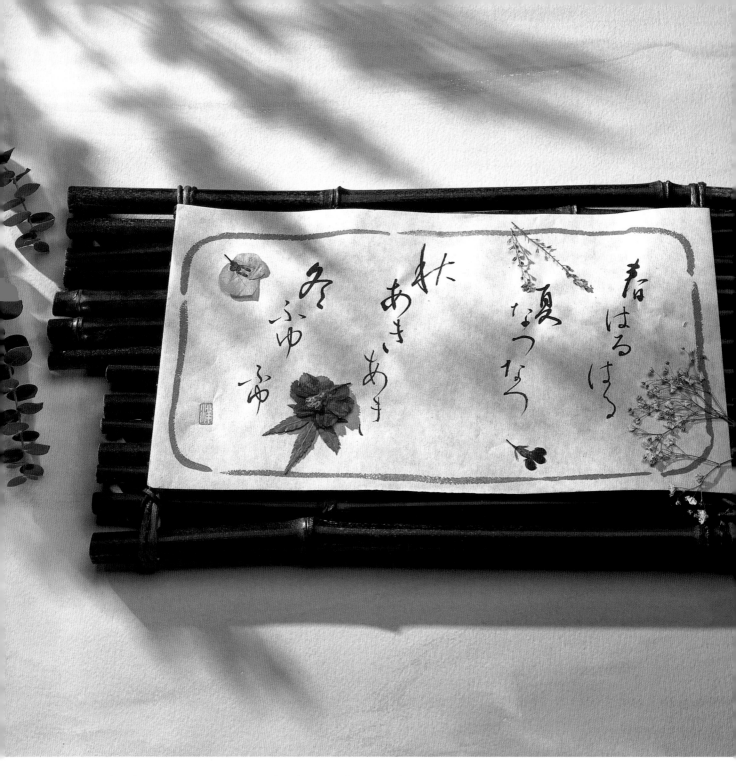

Among other things we Japanese enjoy the changes of seasons between spring, summer, fall and winter. In our traditional poems, *haiku*, a seasonal word is included to share the sentiment. Just writing the names of the seasons in a rather poetic manner makes a nice piece of work. When you are writing a big piece like this, keep in mind the composition of the lines and the shades of ink to make the piece prettier. Then, why not ornament them with some dried flowers to give a little color?

MATERIALS

Writing stock
Small brush
Black ink
Seal and seal ink

FOUR SEASONS' HANGING

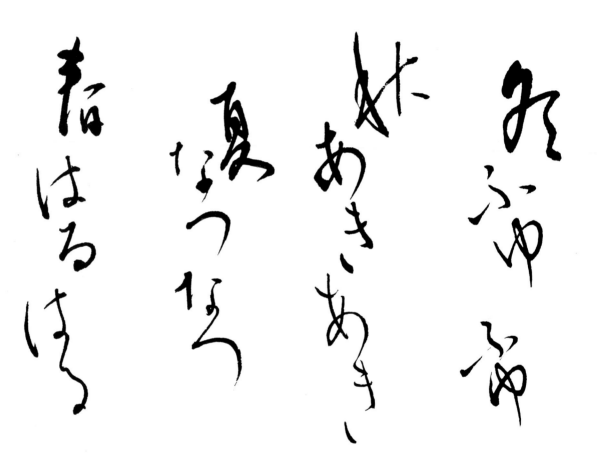

Winter

Start the first season, "spring," on the righthand side. After completing "fall," add a little bit more ink to your brush to start "winter" (above). Begin slightly below "spring" with a *kanji* character, followed by the *hiragana* characters, *fu* and *yu*. Finish by adding a seal.

Fall

The *kanji* character for "fall" appears at the top, followed by the *hiragana* characters *a* and *ki*. In order to get some rhythm, "fall" is put even higher than "spring", its size being larger but its shadiness weaker.

Summer

The *kanji* character for "summer" heads this row, followed by the equivalent *hiragana, na* and *tsu*. To keep an airy composition for the whole piece, this column has been started slightly below the first.

Spring

The first column, "spring" (above), is written on the righthand side of the paper. The top *kanji* character in *gyosho* style is followed by two *hiragana* characters, *ha* and *ru* (see page 44), one in the individual form, with sharp, crisp strokes, the other in *renmen* continuous form (see page 56).

Dharma Postcard

The *dharma*, *bodhidharma* in Sanskrit, is a legendary Buddhist monk who founded Zen Buddhism. Born in India, he traveled to China where he spent nine years in meditation. The legend goes that he lost his arms and legs, and his eyebrows and beard grew to extraordinary lengths. The bodies of *dharma* dolls are round with a weight placed inside at the bottom so that they always stand up when pushed over. Seen as a symbol of accomplishment after resilience, a simple *dharma* is drawn here on a postcard, together with a phrase in *kanji* and *hiragana* characters meaning, "You fall seven times but get up eight times."

MATERIALS

Plain postcard or card stock
2 medium brushes
1 writing brush
Black ink
Red calligraphy or
watercolor ink

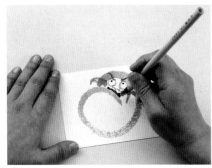

1 Draw the outline of the body using a medium-sized brush with thin ink writing in one movement. Ensure the shading is constant. Imagine the shape of a peach or heart.

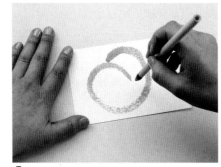

2 Draw the eyebrows, beard, eyes (without the eyeballs), and nose with the same brush, using medium ink.

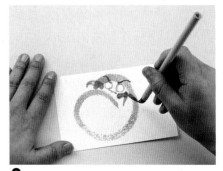

3 Add the eyeballs and mouth with thick, dark ink.

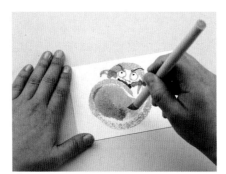

4 Paint the body and the side of the face in red using a second brush.

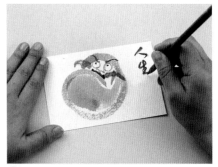

5 The first two characters mean "life." Start with a downward raise followed by a right-falling stroke in *gyosho* style to continue into the second character. This begins with a downward raise followed by the first horizontal, moving from left to right. Follow this with the vertical line from the top to the bottom followed by the second and the third horizontal lines both from left to right.

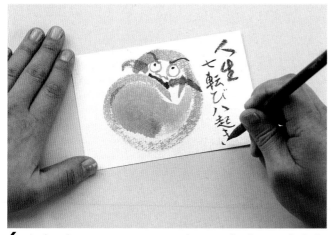

6 The first character, meaning "seven," begins with a horizontal which is crossed by a vertical with a right-angled turn at the bottom, and the second character is "fall," followed by the *hiragana* character *bi*. The fourth character, "eight," looks like a *katakana ha*, and the fifth means "getting up." The sequence ends with the *hiragana* character *ki*.

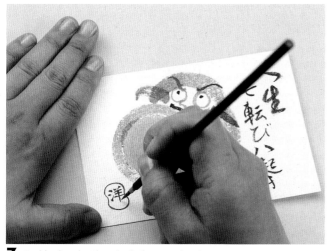

7 Seal by hand with red ink, framing the characters in a *dharma*-shaped outline.

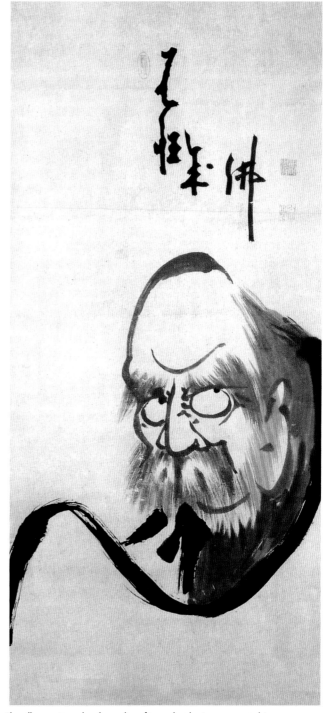

The *dharma* is such a legendary figure that he is represented in numerous paintings and drawings. Those drawn by Zen priests are specially appreciated, and this is an example by Hakuin Ekaku (1685–1768).

SHAKYO—COPYING THE SUTRA

Japanese calligraphy has retained a very strong connection with the development of Buddhism since it was introduced to Japan in AD538. Both the job of copying Buddhist *sutra*, or texts, and the works themselves are known as *shakyo*. Their reproduction has not lost its popularity either as a religious act or as a piece of art.

Here is an extract from one of the most popular *sutras*, "The Heart *Sutra*." The *sutra* itself consists of 262 characters but I chose four letters out of them to compose this little talisman. This piece of *sutra* means "Form is Void."

MATERIALS

Small hardboard paper
Thin, hard-tipped brush
Black ink

1 The first character, literally meaning "color," represents "form." Place this character at the twelve o'clock position of the dial of a clock.

2 Put the second character at one o'clock. Try to make the horizontal lines thinner and the vertical lines fatter so that the character looks solid.

3 The third character is at the two o'clock position. Make an accent at the right falling.

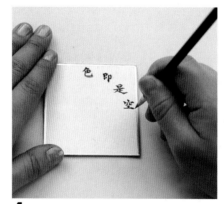

4 The character for "sky" represents the concept of "void." Place it at three o'clock, giving extra emphasis to the blades and vertical lines.

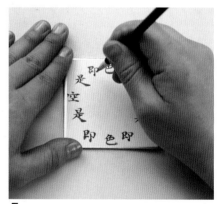

5 Write the same phrase in reverse from twelve o'clock. Then repeat the first character at six o'clock, and write the same phrase twice more, so that the letters can be read in the correct order from twelve and six o'clock, both clockwise and counterclockwise.

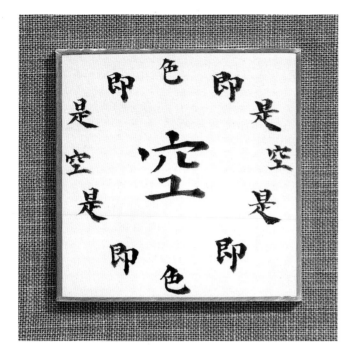

In the original *sutra*, the phrase "Form is Void" is followed by the contrasting phrase, "Void is Form." In order to write this, use the same characters, replacing the fourth with the first, and then the second with the third, repeating in all four quadrants.

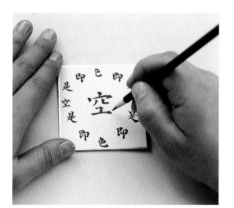

6 Write a larger "void" character in the middle of the paper.

Regarded as one of the greatest *shakyo* ever, Emperor Shomu ordered this *sutra* to be copied in AD741 to be kept at every temple nationwide in order to calm the country. Special gold ink, one of the seven precious colors in Buddhism, is used and some records show that when *shakyo* specialists made a mistake, they were fined according to the number of characters in which they failed!

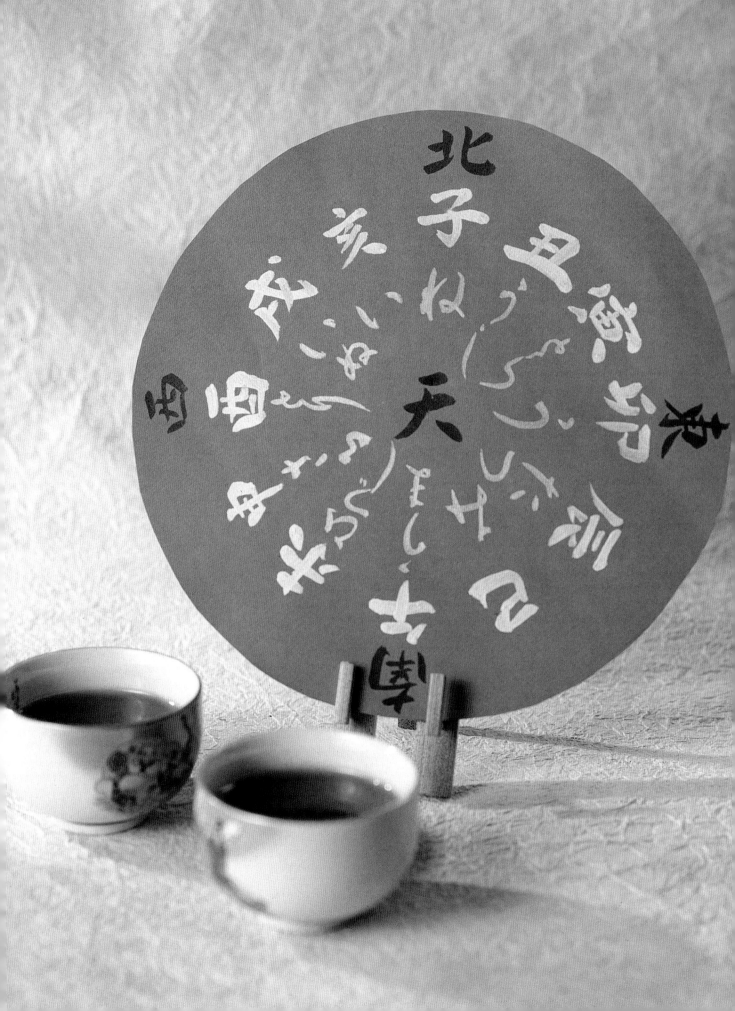

ETERNAL CALENDAR

In the Japanese zodiac there are 12 sacred animals, called *eto*, which each represent a set of years. The animals are the rat, cow, tiger, rabbit, dragon, snake, horse, sheep, monkey, rooster, dog, and wild boar. This zodiac was imported from China, and each year has its own set of characteristics. For example, people who were born in a year of the monkey are said to be good conversationalists, and very active and innovative. To find out which animal represents the year of your birth, look at the table below, or subtract 12 from your birth year until it matches one of the dates shown. The twelve animals are believed to be the guardians of each direction of the compass, starting with the rat in the North. The circular calendar is made up of the animals in both Chinese *kanji* characters, and *hiragana*. The *kanji* symbols for North, South, East, and West are shown at the compass points with the *kanji* symbol for heaven in the center.

For the *kanji* characters, see page 34. For the *hiragana* characters, see page 44. For the compass directions, see page 41.

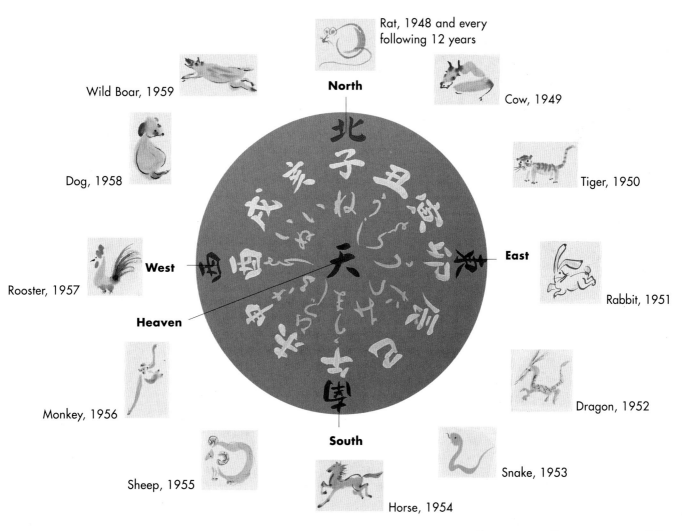

Rat, 1948 and every following 12 years

North

Wild Boar, 1959

Cow, 1949

Dog, 1958

Tiger, 1950

West

East

Rooster, 1957

Rabbit, 1951

Heaven

Monkey, 1956

Dragon, 1952

South

Sheep, 1955

Snake, 1953

Horse, 1954

MATERIALS

Purple sheet of paper
Small brush
Gold ink
Silver ink
Black ink

1 Cut a circle from the purple sheet. Divide it into 12 equal sections using a compass and a ruler. It helps to mark the lines lightly in pencil. Mark 4 concentric circles to divide up the space. Start with the *kanji* characters in silver ink. Position them in a space between the second and third circles from the outside. Begin with the rat at the top, and follow with the cow, tiger, and rabbit. Try to write the characters with even spaces between them.

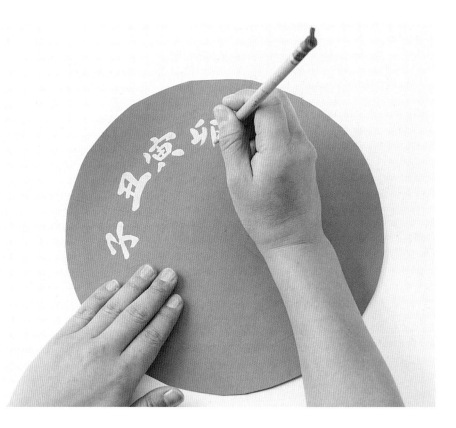

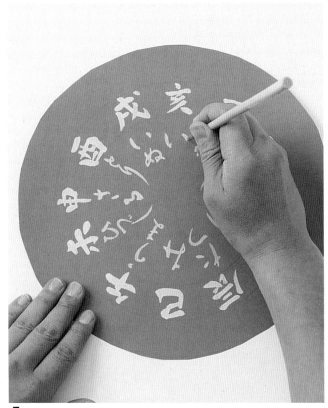

5 Complete the circle with the monkey (*saru*), rooster (*tori*), dog (*inu*), and wild boar (*i*), so that each animal is represented in both Chinese and Japanese characters.

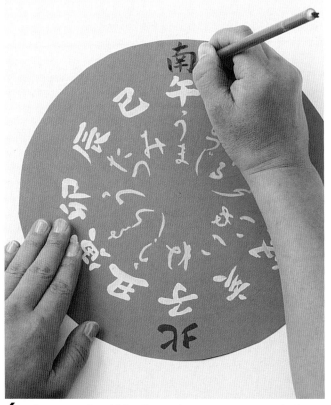

6 In the outer circle, add the Chinese characters representing the four points of the compass—begin with North above the rat and then add the symbol for South below the horse.

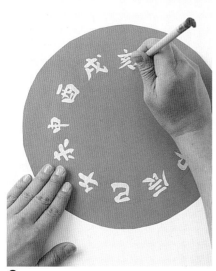

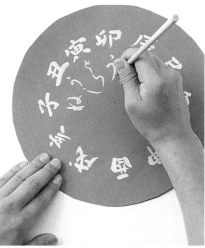

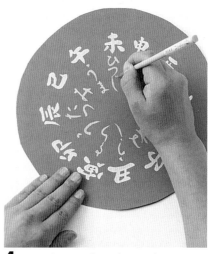

2 Next add the dragon, followed by snake, horse, and sheep. Complete the circle with monkey, rooster, dog, and wild boar.

3 Position the *hiragana* characters in gold in a space between the inner and second circles, so that they appear under the Chinese characters. Begin with the rat (*ne*), followed by the cow (*ushi*), tiger (*tora*), and rabbit (*u*).

4 Write the second set of names beginning at the dragon (*tatsu*), followed by the snake (*mi*), horse (*uma*), and sheep (*hitsuji*). When the word is a single letter, make the character large. If the animal name consists of two or three letters, try to squeeze the characters so that the total length balances the shorter words.

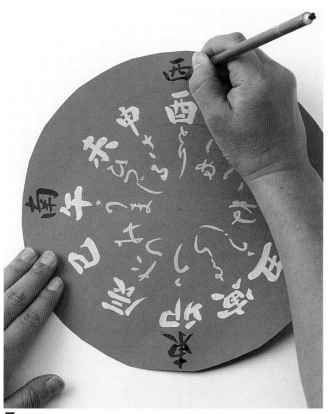

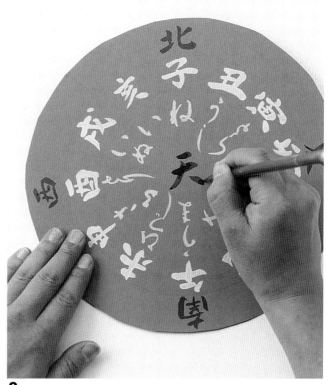

7 Next turn the card and add the symbol for East above the rabbit and complete the compass directions with the symbol for West above the rooster.

8 Finish the calendar by writing the character for heaven (*ten*), in the center of the calendar.

HAIKU HANGING

Japanese people traditionally create *haiku* for special occasions such as birthdays and anniversaries. The *tanzaku* paper tablet is specially made for calligraphy and painting, so is ideal for writing a single poem. This is a *haiku* for New Year; it reads, "On New Year's Day, I made a pleasant trip to view plum flowers." See page 121 for other *haiku* to copy.

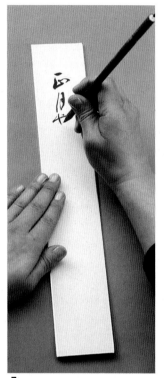

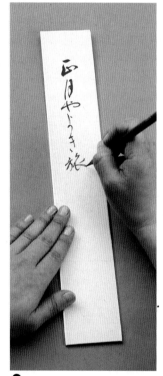

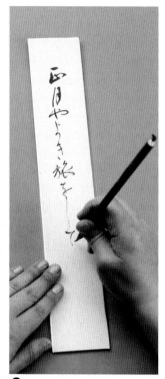

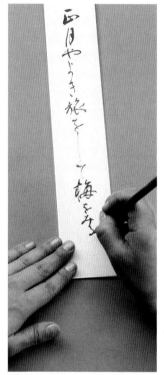

1 Leaving a little space at the top, start with a small horizontal stroke followed by the vertical on the left, which bends toward the upper right making one dot followed by another. The second character is "moon" in *gyosho* style—together the two characters mean "New Year." The third character is the *hiragana* character *ya*.

2 The *hiragana* characters *yo* and *ki* are followed by *kanji* characters meaning "trip." Ensure that the *kanji* is bigger than the *hiragana*.

3 Add three further *hiragana* characters: *wo*, *shi*, and *te*. Enjoy the way the ink's shade changes as the brush begins running out of ink. Slow down your movement to avoid too much patchiness, though this patchiness is part of a work's charm.

4 Get more ink for the finale. The first *kanji* means "plum" followed by *hiragana* characters *wo*, *mi*, and *ru*.

MATERIALS

Tanzaku paper tablet
Brush
Black ink
Seal and seal ink

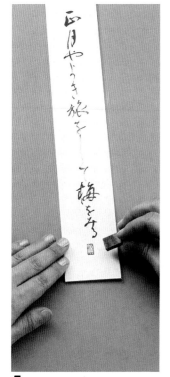

5 Place a seal, leaving approximately the same space at the bottom as at the top of the tablet.

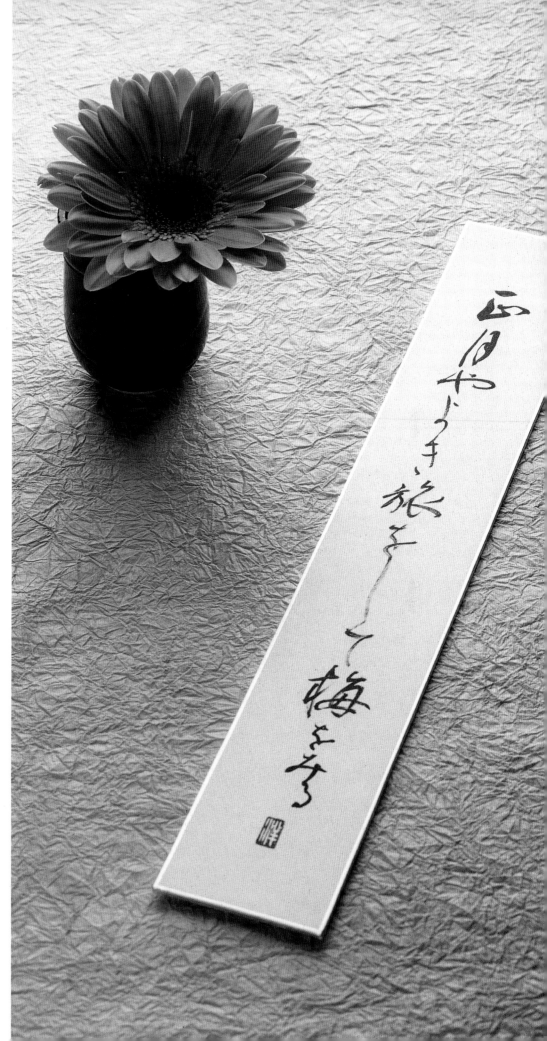

ZEN T-SHIRT

This simple circle is the Zen Buddhist sign of completeness, which represents your state of mind. The figure itself is called *yen*, the same sound as the Japanese currency! Here I have used a middle-sized brush to vary the shades produced, but if you prefer a bolder stroke you can use a larger brush.

MATERIALS

100% cotton T-shirt
Black textile ink
Brush
Card
Masking tape
Seal and seal ink

ZEN

The circle of infinity is one of the most enduring themes in zen calligraphy. Along with the *ichi*, also known as the "original line," these symbols are used to illustrate one of the key principles of Zen Buddhism, the expression of the inexpressible.

As well as art, true Zen calligraphy is a meditation for both the artist and the viewer; it is important for the calligrapher to reach a state of "no-mind" contemplation, whereby spiritual ideas and artistic skills are combined to produce a piece that represents a state of enlightenment.

However, in the true Zen spirit of contradiction, the eternal circle can manifest just a moment, a fragment of time that reveals both a personal and a philosophical view of the completeness of life, with one breath, one brush, and one mind.

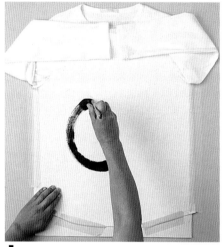

1 Lay the T-shirt completely flat. Place the card inside the T-shirt to prevent the ink seeping through to the back, and fix the T-shirt in position using the masking tape. Start at the bottom and paint a circle in a clockwise direction.

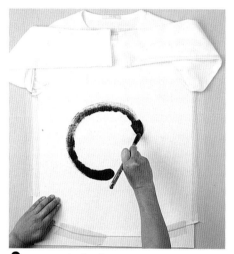

2 Keeping the brush pressure even, rotate the brush from your shoulder, breathing out as you work.

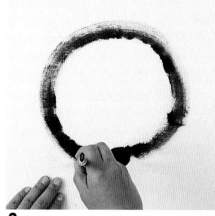

3 Finish painting the circle so that it joins up perfectly. The circle should be created in one continuous movement.

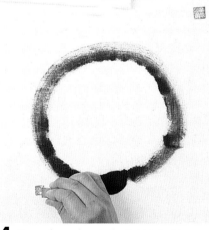

4 Stamp the seals onto the T-shirt. Position them so that the whole design is well-balanced. In this case the upper seal is farther away from the circle than the lower, as the circle itself is toward the left-hand side of the T-shirt.

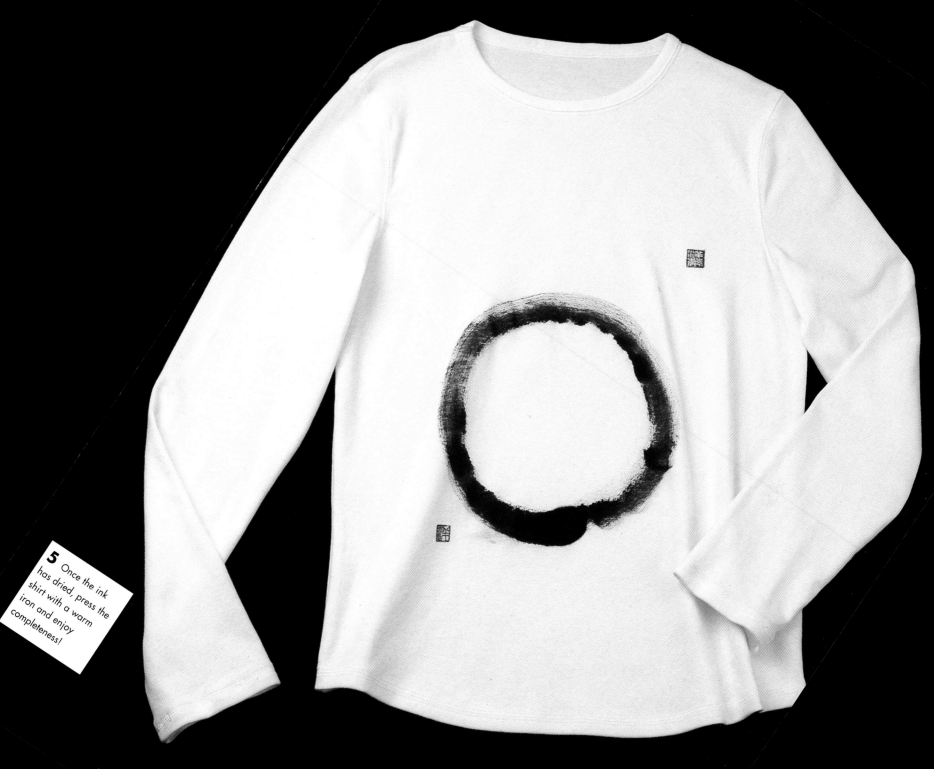

5 Once the ink has dried, press the shirt with a warm iron and enjoy completeness!

NOREN JAPANESE CURTAINS

A *noren* is a hanging cloth or drape that was first used as a windbreak, before it developed to be used on store-front entrances, usually dyed with the store's name, as in the photograph on page 9. As it is very light and easy to put up, the *noren* has gained popularity in interiors, especially as a partition between rooms. I have made two patterns of *noren* here. The first shows the words *A Un*—derived from Sanskrit, meaning "the beginning and the end" in esoteric Buddhism—in *hiragana* characters. The second shows the word "bamboo" written in a *kanji* character alongside a painting of bamboo.

A Un Design

MATERIALS

Pale green cotton cloth (54 x 46 in [135 x 110 cm]) for Bamboo pattern
Ivory cotton cloth (54 x 46 in [135 x 110 cm]) for *A Un* pattern
Purple embroidery thread
Red thread
Black, water-soluble dyeing ink
Big brush (for characters)
Flat brush (for the bamboo stick)
Medium brush (for the bamboo leaves)
Extra plates to make the ink weaker for bamboo painting with water
NB: Ink is absorbed differently on cloth from paper. Practice your strokes on a spare piece of cloth before starting work on the curtain.

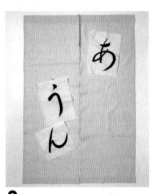

1 Make up a *noren* from two pieces of cloth with an integrated loop at the top, hand-stitched together with purple embroidery thread.

2 Decide the design of the characters on a separate piece of paper and mark the position on the *noren* with a piece of red thread. Here they are placed out of balance to add dynamism.

3 Stitch the cotton back once so that your stroke positions are not lost.

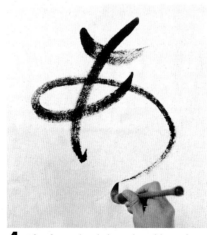

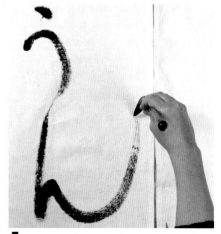

4 After fixing the cloth on the table so that it doesn't move, write the *hiragana* character *a* at an angle. Some distortion was applied to give some rhythm.

5 Write two *hiragana* characters, *u*, and *n*. Make the *u* smaller to give a rhythmic impression. When dry, iron the *noren* and hang it up by putting a bamboo pole through the top loop.

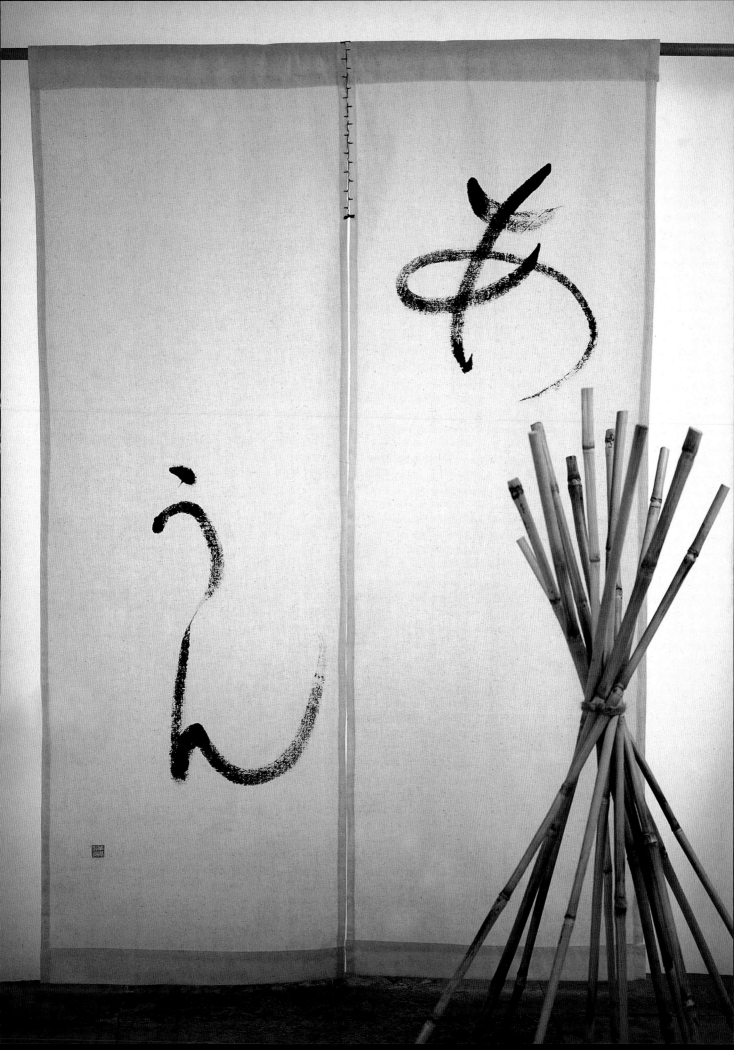

Bamboo Design

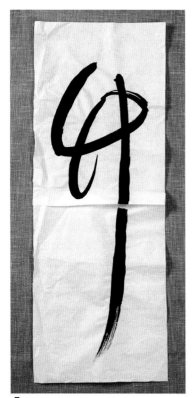

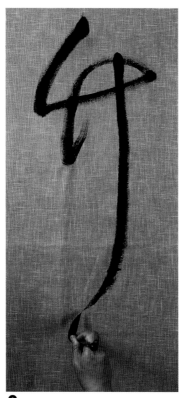

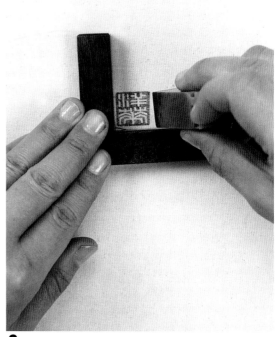

1 Decide the position of the Chinese *kanji* character "bamboo."

2 Write it on the cloth, making the last stroke extremely long to follow the shape of the *noren* .

3 Stamp your seal at the lower left corner. After it dries, iron the *noren* and hang it up by putting a bamboo pole through the top loop.

Drawing the bamboo

Prepare three shades of ink. Draw bamboo sketches at the bottom of the other side of the *noren*.

1 Apply weak ink with a flat brush to depict the stick, starting from the bottom and pushing upward three times with a little gap in between each stroke.

2 Apply medium ink with a tip of the brush to depict the joints and small twigs.

3 Depict the leaves using thick ink and a medium brush. Start near the twig and drag the brush away. (For final image see right.)

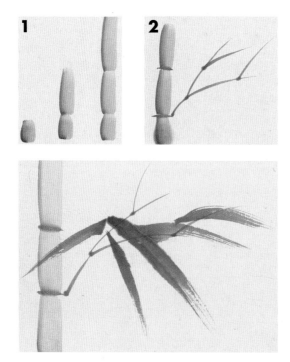

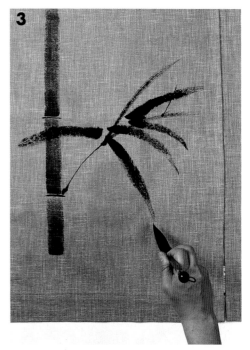

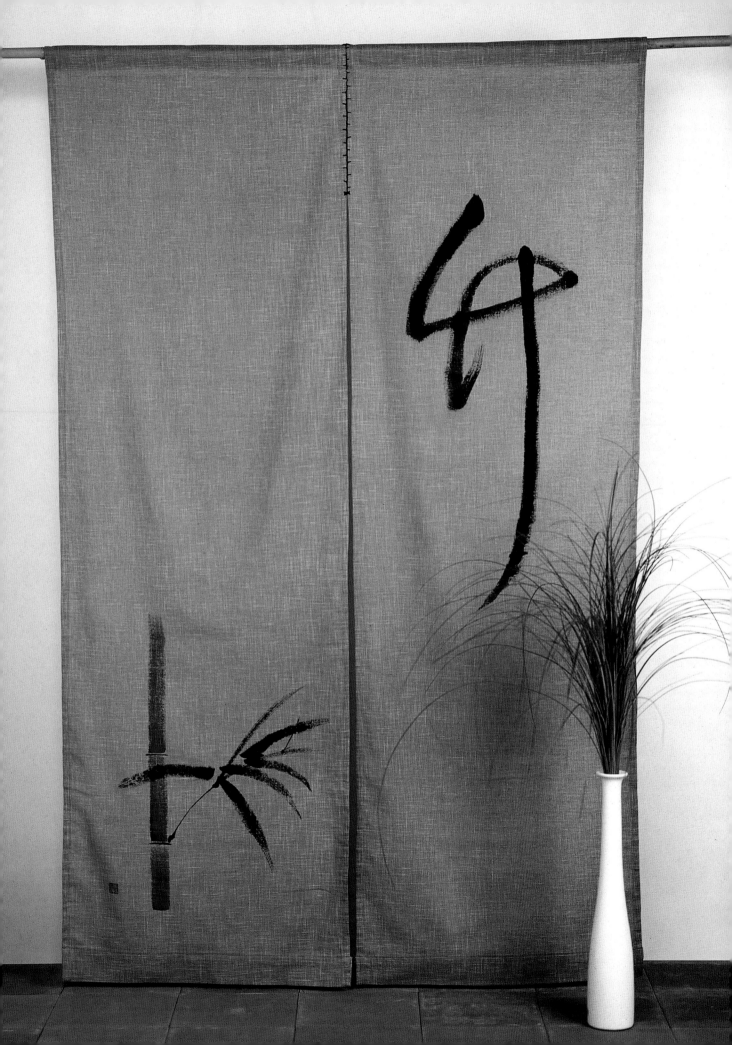

PEBBLES OF NATURE

Before paper was invented characters were carved in such materials as stone, wood, and metal. Today, examples inscribed in stone can be found at ancient temples and shrines. The stone represents eternity and therefore stone carving is very much respected. Here, instead of carving into stone, which requires special skills and facilities, I wrote Chinese *kanji* characters to represent the natural elements on the small pebbles. The characters are written in seal style, called *tensho* (see pages 34–35). The strokes are consistent in width, revealing their origin in carving rather than brushwork.

 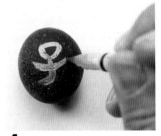

1 Find a pebble that fits the shape of the character. This character in the *tensho* style, representing water, requires both width and length, so I chose rather a round stone .

2 This is moon. Choose a long pebble for this character.

3 For the character "fire," I chose a rather long pebble so that the way in which fire flames go up high can be depicted.

4 This character means "child," depicting a figure standing with open arms.

5 Pebbles are then placed in order to match up with the days of the week. From top left, "Sun" (Sunday), "Moon" (Monday), "Fire" (Tuesday), "Water" (Wednesday), "Tree" (Thursday); 2nd row: "Gold" (Friday), "Earth" (Saturday); 3rd row: "Child" (absorbing all elements). Place the pebbles as a good luck charm or talisman in your living space.

MATERIALS

White and black pebbles
Black dying ink
Gold poster color
Small brushes

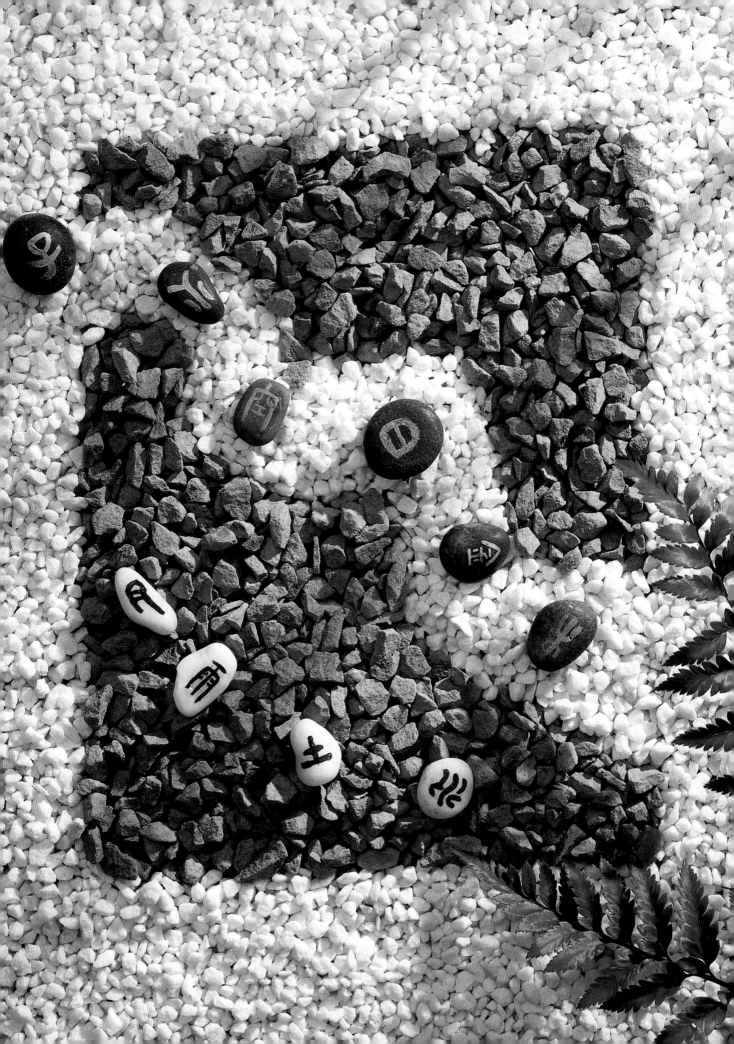

SHOOTING STAR LAMP SHADE

The Japanese phrase that means "shooting star" is *nagareboshi*. I wrote *na*, *ga*, and *re* in *hiragana* characters, and *boshi* in the Chinese *kanji* character that means "star."

MATERIALS

Pergamenata paper
(imitation vegetable
parchment) or any other
heavy, translucent paper
Black ink
Medium or large brush
Paper clips, or adhesive
tape

1 With black ink write *nagareboshi* at an angle across the paper.

2 Write *nagareboshi* a second time in weaker ink at an angle to the first line.

3 With the shade still spread out, add a *kanji* star in gold ink to give the shade more shine.

4 Roll up the paper into a cylinder and join the two ends together using paper clips or adhesive tape. To prevent fire ensure that the light bulb never has any direct contact with the paper.

WAX CUSHION

Wax dyeing is an art with a long history in Japan. It gives calligraphy another interesting impact. Here, I wrote the *kanji* character meaning "sea" and reflected this by dyeing the cushion blue.

1 Place your cloth—prewashed to ensure best results—on top of some newspaper so that the wax won't soak through. Melt the waxes together by mixing 1 part candle wax with 3 parts paraffin wax then putting them in a heat-resistant container in boiling water or the microwave oven. When using a microwave oven, make sure to cover the container so that melted wax does not splash inside the microwave. It is also handy to prepare a small dish to hold the brush so that the liquid wax won't drop on the cloth.

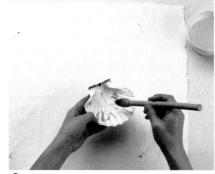

2 Dip your brush into the hot liquid wax and bring it over to where you start your stroke, holding a small dish underneath the tip to catch any drips.

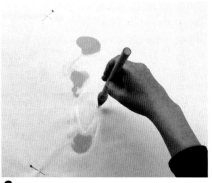

3 Begin by placing three dots near the top of the cloth.

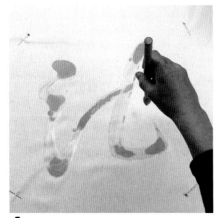

4 Dip your brush again, warming the wax again if the temperature has dropped.

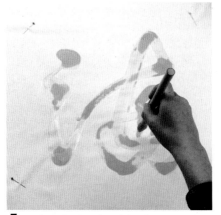

5 Add the final stroke of the character denoting the sea. Keep the cloth flat and let it dry completely.

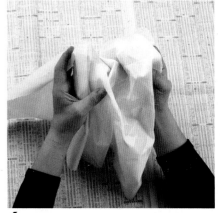

6 When the wax is completely dry, hold the cloth in your palms and rub it a little to make some cracks in the wax.

MATERIALS

Plain cushion
White cotton cloth or poplin,
to cover entire cushion
Candle wax
Paraffin wax
Brush for wax
Brush for dye
Blue and white dyeing inks
Newspaper

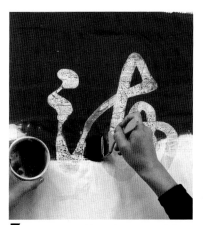

7 Cover your table with paper and then lie the cloth flat on top of it. Start dyeing.

After you finish dyeing, let the cloth dry before removing the wax. Sandwich the cloth between two sheets of paper and press with a hot iron. As the wax melts it is absorbed by the paper. Repeat with new sheets until no more wax can be removed. You can finish by adding a seal in white dying ink.

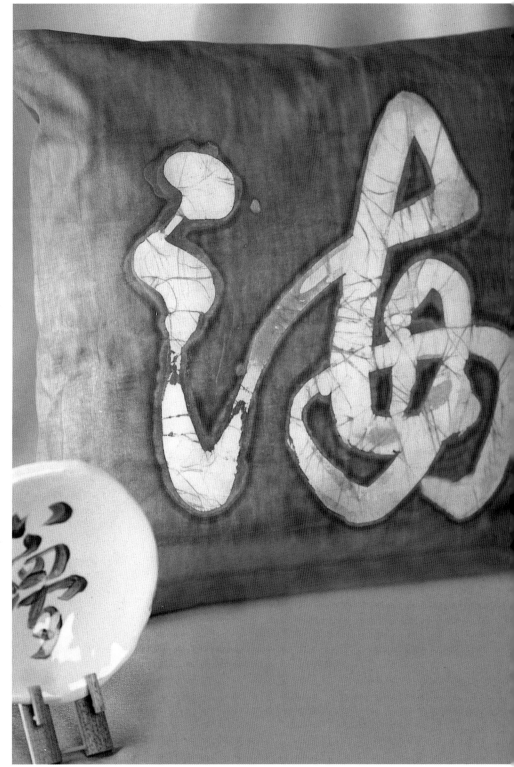

POETRY CUSHION

The flow of a poem looks nice on a simple cushion cover. The fall colors are reflected in the poem, which translates as, "When we feel the fall breeze, those who are not philosophical usually start to think about life."

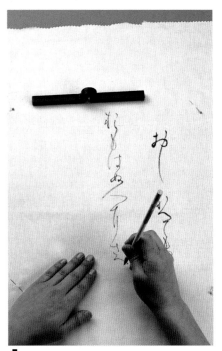

1 Wash and dry the material to ensure best results when dyeing. Pin down a frame that replicates the end shape of the cushion, allowing you to plan your composition. Start writing the poem (*waka*) just as you would on paper. The cloth may have a different absorption rate to paper, so test a few strokes on the material before you start.

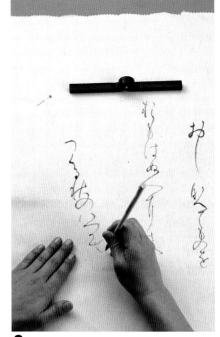

2 The final line should be slanted a little bit toward you.

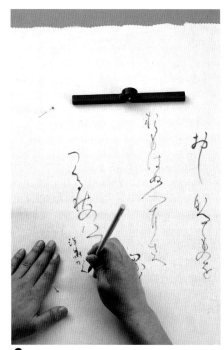

3 Write your name. Traditionally, the form is your first name followed by the *hiragana* characters *ka* and *ku*, meaning "written by."

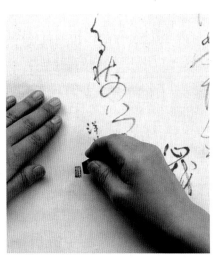

4 Using the seal paste, place a red seal as an accent.

MATERIALS

- Oatmeal-colored cotton cloth, big enough to cover the cushion
- Black dyeing ink
- Seal paste

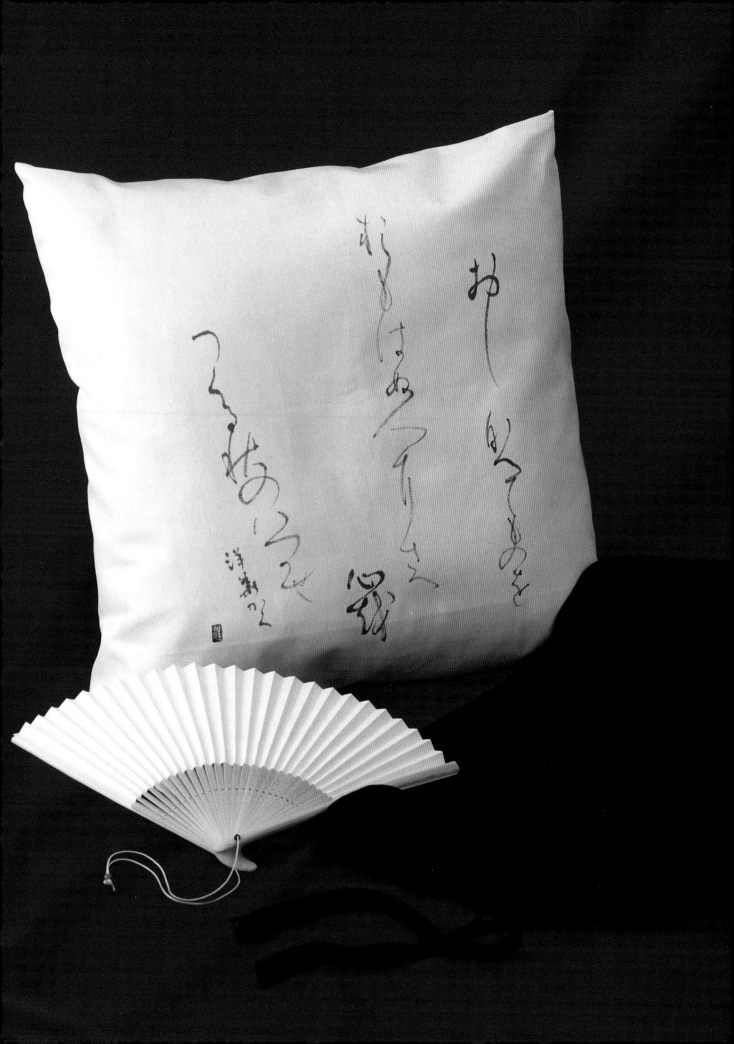

MAKING A SIMPLE SEAL

Making seals is fun, and you can create the character you choose in a variety of styles. Seals can be made from stone or wood, but here I used rubber, which is very easy to handle. One of the most popular girl's names, Olivia, is carved here in *katakana* characters (see page 124).

MATERIALS

Brush
Ink
Calligraphy paper
Rubber sheet
Ballpoint pen
Tracing paper
Cutting knife
Carving knife
Knob
Stamp mat
Glue

1 Make a design with a brush and ink on calligraphy paper. I wrote "Olivia"—*o, ri, bi,* and *a* in *katakana* from top to bottom—angling and twisting some strokes to add interest.

2 Turn the paper over and copy the pattern onto the rubber sheet in its mirror image. You can use tracing paper to make your work easier.

3 Start carving around the outside of the design with a cutter knife, following the line along one side. Wear protective gloves to carve.

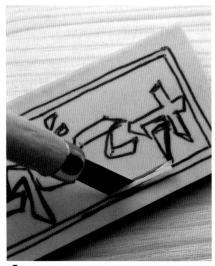

4 Repeat from the other angle in order to carve out the frame.

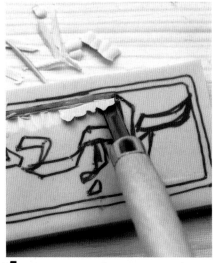

5 Start carving out the inner section of your design.

6 When all the carving is complete, attach a knob to the back of the stamp with using superglue. Anything you can hold on to will do; here I used an old doorknob.

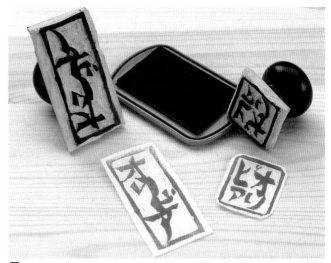

7 To match "Olivia," I used an olive-colored stamp mat. The smaller stamp shows the same name written in two columns, the *o* and the *ri* on the right.

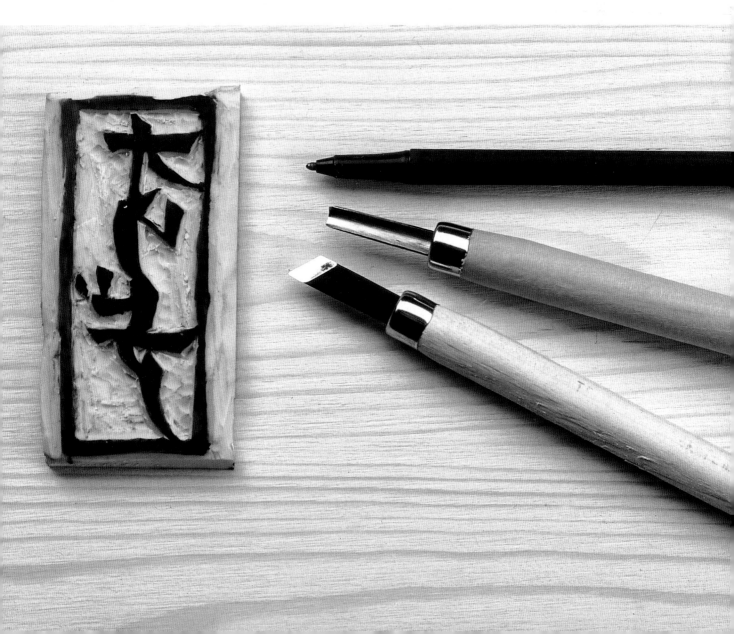

WALL SCROLL

Another popular tablet format—this time square—is the *shikishi*, which has been displayed here as a wall scroll. A *Shikishi* can be bought as a simple white tablet with golden framing or, as shown here, they are available already beautifully decorated. This poem reads, "Cherry blossoms can remind us of our deepest memories."

1 Start the first line with the *hiragana* characters *sa* and *ma*, followed by two dots. This looks like the *hiragana* character *ko* with much bigger space, but represents the repetition of the characters above. The last *hiragana* character is *no*.

2 Begin the second line slightly above the first to create some rhythm. Try not to get additional ink while writing the *hiragana* characters *ko, to, o*, and *mo*—enjoy the patchy effect and slow down if your brush is running out of ink.

3 Get a little additional ink before continuing the line with the *hiragana* characters *hi* and *ta*, followed by the *sogana* character *su*.

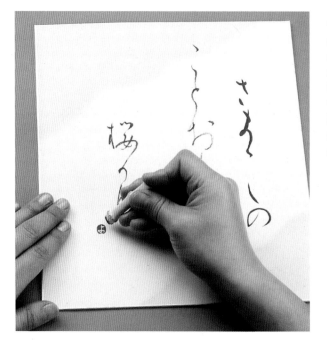

4 Start the final line a little bit apart from the second line and slant it slightly toward you. The first *kanji* character means "cherry blossom," followed by the *sogana* characters, *ka* and *na* (see pages 58–59). Add a seal.

MATERIALS

Shikishi tablet
Brush
Black ink
Scroll

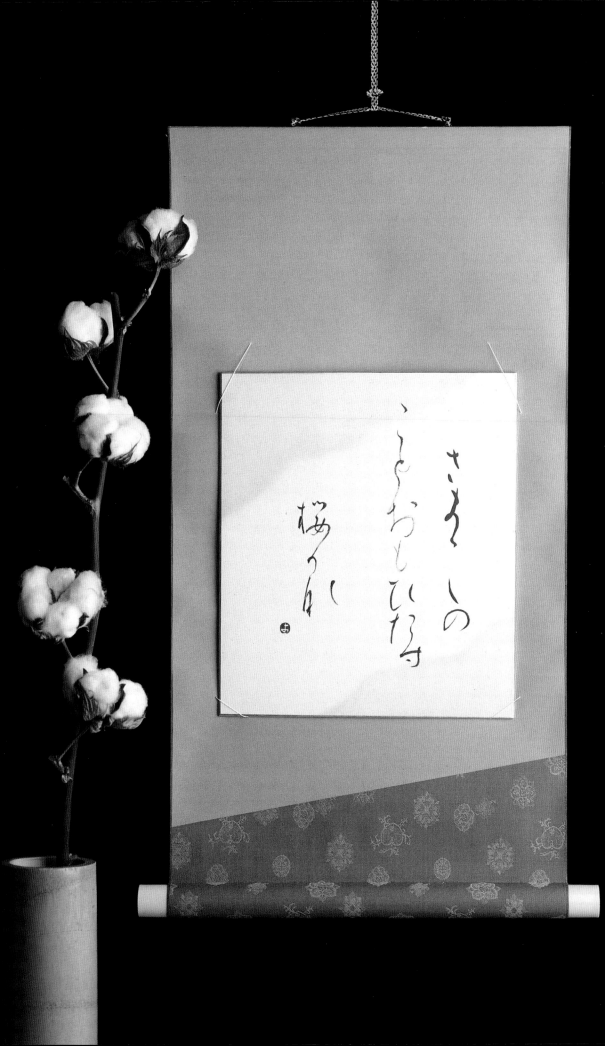

CALLIGRAPHY CERAMIC DISHES

Ceramics have a long and important history in Japan. Here, examples have been fired in the *raku* style. The white *raku* dishes have red characters which both mean "heart," the square dish is *kanji*, and the round one is *hiragana*. One brown dish, which has the *sogana* character *fu*, deriving from the *kanji* character meaning "cloth," also has a cloth pattern applied, the other two have different versions of the character *wa*, meaning "harmony." With calligraphy, you can make your dishes quite eloquent! You will probably have to go to your local kiln or craft center to have your bowls fired, and be sure to ask for advice on handling clay and glazes.

1 Shape a lump of clay into a rough cube by fixing it in between two piles of tiles of the same height and roll up and down to make the surface even.

2 Slice away the top layer to get a perfectly smooth surface for the plate.

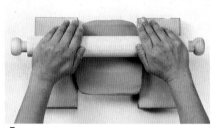

3 Remove the uppermost tiles and slice away a layer of clay to get the material for a plate.

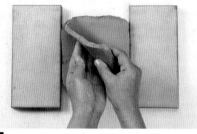

4 Carefully remove the slice of clay, ensuring that you do not make any small breaks in the surface that will crack in the kiln.

5 Use a ruler to cut away the rough edges, leaving a square sheet of clay.

6 Scrape a character into the top surface— In this sample a *hiragana wa*, which derives from the *kanji* meaning "harmony." Don't carve too deep since it could cause a crack when fired.

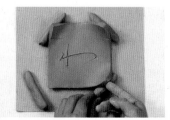

7 Make little "pillows" out of unneeded clay to put underneath each corner to shape the plate. The clay is still soft, so handle it gently. Then, dry it out until it is ready to fire. After the first firing, apply a brown overlayer, and fire again.

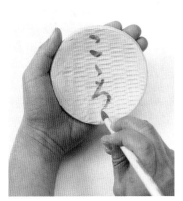

To create this bowl, slice the clay thinly and mold it into a round dish. Edge off around the sides of the dish and, after the clay dries, visible when it turns white, write characters with red underglaze—here the *hiragana* characters *ko, ko,* and *ro,* meaning "heart"—and fire. For this and the following dishes, after firing once with a coating of underglaze, apply translucent overglaze and fire again.

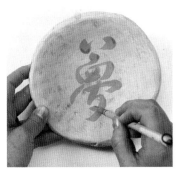

Prepare the clay in a square as above. Once it has dried, write the *kanji* character meaning "heart" using red underglaze, and fire.

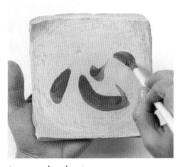

Use the same method to prepare a round dish, writing the *kanji* for "dream" in blue underglaze.

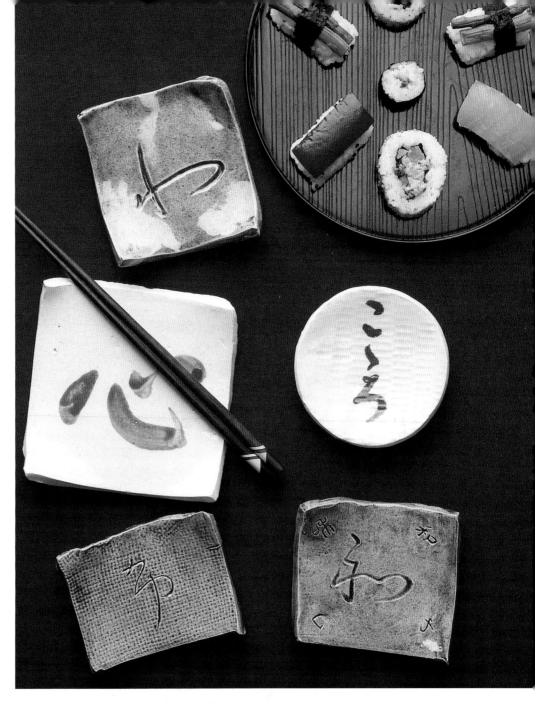

MATERIALS

Clay
Roller
Slicer (made of wire)
Tiles of the thickness of the plates you like to fire.
Needle/small spatula
Brush
Underglaze (blue/red)
Food-safe overglaze (brown/translucent)

JOY, PEACE, LOVE, AND HOPE

Introduce "joy," "peace," "love," and "hope," into a gathering for family and friends with these brightly-colored origami party favors adorned with key spiritual motifs from the East. Simple to make—all you need are four small pieces of writing paper. The containers are surprisingly robust and are ideal for snacks, nibbles, and candy. Each Japanese calligraphy motif is written in both *kanji* and *hiragana* characters. *Kanji* was imported from China in the sixth century, while *hiragana*, a script unique to Japan, was developed from the ninth century onward. A favorite artform of the Imperial royalty of Japan, the elite *hiragana* calligraphy was developed by aristocratic ladies of the court, and is still celebrated today for its flowing, feminine elegance. Japanese calligraphy combines *kanji* and *kana* freely to create delicate, yet graphic, artworks to treasure.

Paper Folding—Party Favor Container

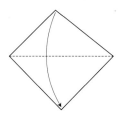

1 Fold a square piece of paper in half, corner to corner.

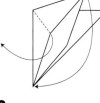

2 Fold in half again, this time along the longest straight edge.

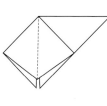

3 Reshape the topmost opening by pulling the top corner down to the bottom.

4 You are left with a diamond shape with a long point to the top right.

5 Turn the whole thing over and fold the long point across to the top right.

6 Placing your thumb inside the opening, reshape the flap, to leave a simple diamond shape.

7 Fold uppermost pair of flaps forward until they meet in the middle. Turn the paper over and repeat on the reverse.

8 Open out the four small flaps at the front evenly, so that a six-sided figure is created.

9 Turning the paper on its side, lift up the top flap and push it back underneath itself.

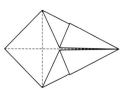

10 Repeat on all the other flaps.

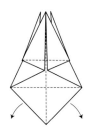

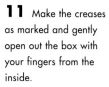

11 Make the creases as marked and gently open out the box with your fingers from the inside.

MATERIALS

4 squares colored paper
10 x 10 in (25 x 25 cm)
Writing brush and black ink

Joy

1 To balance the *kana* calligraphy, all the favor motifs are also written in Chinese *kanji* characters in scroll style. Start the Joy favor with the *kanji* character. Create a top horizontal, and pull down with a vertical stroke. Follow with two horizontals from left to right; a short center stroke and a longer base stroke. Create two strokes at the base. Repeat the character on the opposite flap.

2 Move across the favor to create the *hiragana* "joy" character, *yorokobi*—here written as *yo-ro* and *ko-bi* in two lines. Beginning at the top right, follow the photograph, continuing through this sequence to the second letter in a flowing line.

3 Move to the opposite flap. Write the top line, to balance its opposite, and start the first dot of the second line (*ko*) slightly below the first line of this section.

Peace

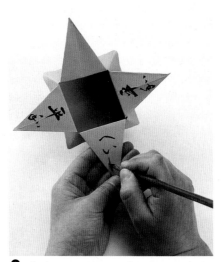

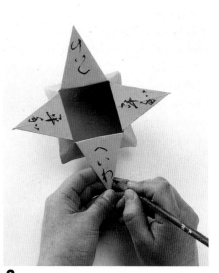

1 The *kanji* character "peace" is made up of two characters. Start with a top horizontal stroke followed by two dots underneath. Then write a horizontal followed by a vertical slash without a final stop. The second character is the same as the sogana wa on page 58. Repeat the character on the opposite flap.

2 The *hiragana* "peace," *heiwa*, consists of 3 syllables or letters. Write the first letter, *he*, in the shape of a mountain or summit. Make the tail of the right side slightly longer than the left.

3 Arrange the next two characters so they look as if they are gathering together to enclose a space. Write the second letter, *i*, as two short vertical strokes, but curve the strokes outward, with the left stroke longer than the other. The third letter, *wa*, begins with a vertical line followed by a snake-like vertical stroke.

Love

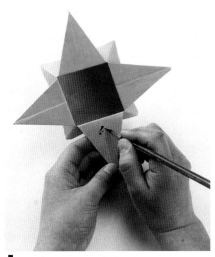

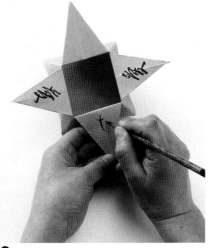

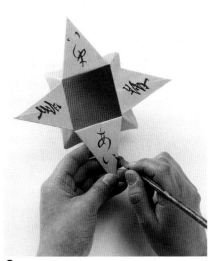

1 For "love," start with the Chinese *kanji* character. Begin with a short downward raise, then add three dots, the third to the left. Now create a roof-shaped stroke, then beneath it a "heart," and a final stroke that replicates the bottom of the character for "Summer" (see page 40).

2 The *hiragana* for "love"—*ai*—is two characters. To create elegance and openness, write them loosely. Start the *a* (see page 44) with a short horizontal stroke followed by a vertical; finish with a curve round the vertical.

3 Continue with the *i* (see page 44). Begin with the left stroke, then create a shorter stroke to the right. Keep a generous space between them to create a heart shape.

Hope

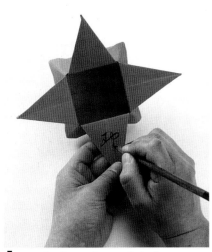

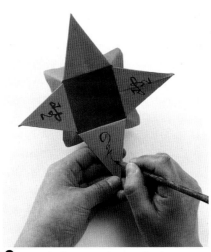

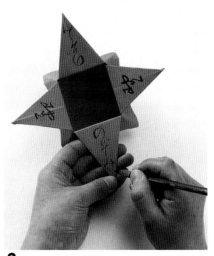

1 Start the "hope" favor with the *kanji* character. Made up of three strokes, start on the left before creating two further strokes, all with a single flowing movement of the brush (see page 50).

2 Begin the *hiragana* character for "hope," *nozomi*. Start with *no* at the center and looping to the right, followed by *zo* beginning with a dot on the left of which the end shoots off to the upper right going left-down, then horizontally to the right, ending by moving downward with a "c"-like curve. Try to write it in a continuous manner.

3 Draw the last character, *mi*, with a hook to the right, followed by a downward vertical. Then twist the brush in a little loop; continuing to the right. Keeping the brush on the paper, finish with the last horizontal.

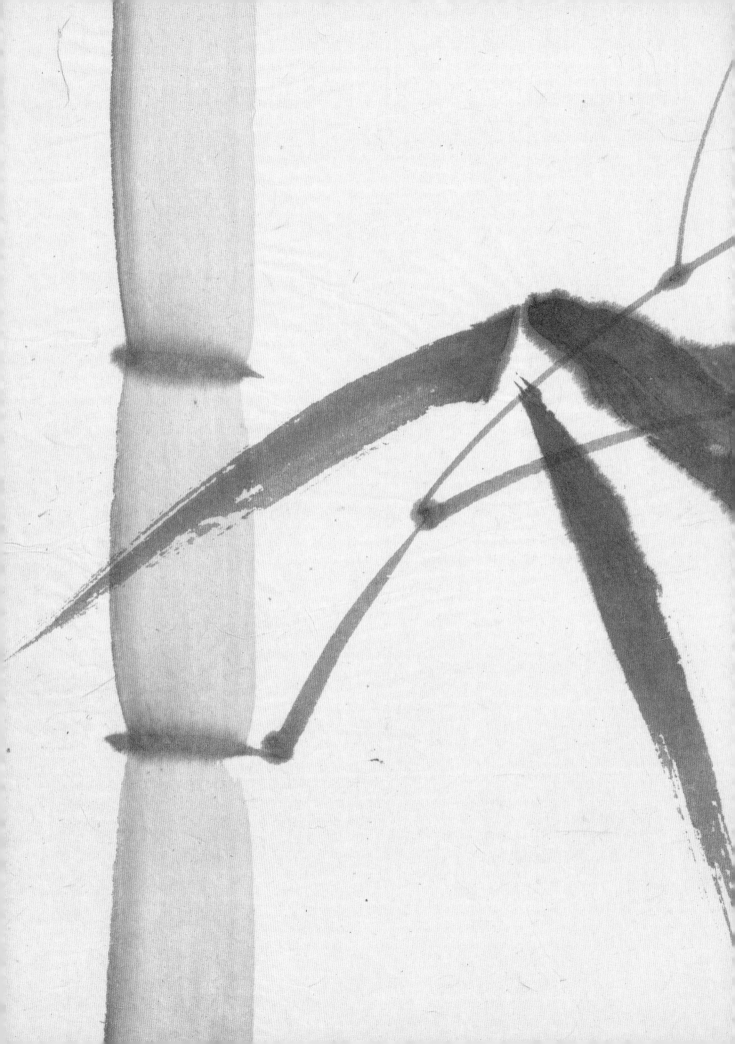

INSPIRATIONS

All the projects can be personalized or amended to make them particularly appropriate for you. Mark a waxed cushion with the name of a friend or family member (pages 124–127) to make it extra-special for them. One hundred of the most popular names for girls and boys are included with instructions for creating others in case your own name is not included. Alternatively, use any of the poems, proverbs, or mottoes (pages 120–123) to mark a project with an idea that is meaningful for your own life. With phrases describing different emotions and feelings, you should be able to find a piece of Japanese wisdom fitting to yourself that you can replicate on your projects.

POEMS, PHRASES, AND PROVERBS

You can use the following calligraphy pieces to personalize your work. They comprise a selection of *waka* poetry (Japanese poems of 31-syllable developed from the 8th century onwards) and *haiku* (17-syllable poems first formed in the 18th century), and examples of Eastern wisdom including elliptical Zen proverbs, as well as traditional phrases and sayings from both the East and the West.

Waka
Taken from *One Hundred Poems by One Hundred Poets* (13th-century *waka* anthology)

The Changing World
I have not noticed that the colors of the flowers have changed while I'm presenting myself to the real world.

Ancient Beauty
Oh, the wind in heaven, could you please stop the flow of the sky between the clouds, so that we can enjoy watching these heavenly girls dancing for one more while.

Separation
What a long night I'm spending on my own! It's as long as the tail of the mountain bird which is said to spend the night alone before being reunited during the day.

Haiku

菜の花や月は東にはは西に

Spring

In front of me is a rapeseed field with the moon rising in the East and the sun setting in the West.

山路きて何やらゆかし すみれ草

Spring

Walking up the mountain road, I catch sight of a little violet trying to tell me something.

閑かさや岩にしみいる蝉の声

Summer

On a quiet summer day, all you hear is the sound of the cicadas against the rocks.

古池や蛙とびこむ水の音

Summer

Oh, old pond, all we can hear is the sound of a frog jumping into you.

生きて仰ぐ空の青さよ赤とんぼ

Fall

What a beautiful blue sky the red dragonfly is admiring, this moment is only possible if you are alive.

名月やたたみの上に松の影

Fall

A beautiful moon is spreading a shadow of pine trees across the *tatami* mat.

旅に病んで夢は枯野をかけめぐる

Winter

Now I've fallen sick while traveling—my dream is running wild in these barren fields.

ゆく年の光 そめたる星仰ぐ

Winter (to mark the end of the year)

Above me I admire the stars lit by the sky of the passing year.

Hidden Beauty

White daisies are all covered with snow. How can I pick the flowers hiding themselves in the white snow?

Japanese Proverbs

弘法も筆のあやまり

Fallability

Even Kobo (Kukai) makes mistakes in writing. [Everybody is prone to mistakes.]

案ずるより産むが易し

Bravery

Fear is often greater than actual danger.

待てば海路の日和あり

Patience

Patience gives you good luck.

残りものには福がある

Unexpected Fortune

What's left over could be the best thing.

住めば都

Home

Once settled in, that's the kingdom for you.

言わぬが花

Tact

Some things are better left unsaid.

Zen Proverbs

春は花 夏ほととぎす 秋は月
冬雪さえて すずしかりけり

The Seasons

What is spring? A flower. What is summer? A cuckoo. Fall? The moon. Winter? Snow.
Now, what are you? What do you want to do?

松のことは松に習え 竹のことは竹に習え

Knowledge

Ask pine trees about pine trees. Ask bamboo about bamboo. Always look for the essences. (Matsuo Basho)

Expectation

Just the way things are supposed to be. Just the way you are supposed to be.

人を呪わば穴ふたつ

Tolerance
When you curse someone, you are cursing yourself.

アバタも　笑くぼ

True Love
Blemishes on the face can be seen as charming dimples, love is blind.

雨降って　地固まる

Positive Thinking
After a storm, comes the calm.

笑ふ門には福来たる

Happiness
A smile invites happiness.

父の愛は　山より高し
母の愛は　海より深し

Family
A father's love is higher than a mountain. A mother's love is deeper than the sea.

よき師よき友は一生の宝なり

Learning and Friendship
Good teachers and good friends are your life-long treasure.

実るほど頭の下がる稲穂かな

Modesty
The more mature the rice ear grows, the lower it falls. [The wiser you are, the more modest you get.]

和をもって尊しとなす

Harmony
Harmony is to be respected. (Prince Shotoku)

継続は力なり

Hard Work
Diligence is the source of empowerment.

習うより慣れよ

Commitment
Just keep practicing. Practice makes perfect.

100 KATAKANA NAMES

Over the following pages, written in *katakana* characters, are 50 of the most popular names for both girls and boys. If your name is not shown, use the letter and sound charts on pages 60–63 to build up the syllables, adding an "o" to any name ending in "t" or "d," or a "u" onto names ending in any other consonant, for example turning "Rachel" into "Rachelu."

Girls' names

エミリー
Emily

マディソン
Madison

ハナ
Hannah

エマ
Emma

アレクシス
Alexis

アシュレー
Ashley

アビゲイル
Abigail

サラ
Sarah

サマンサ
Samantha

オリビア
Olivia

エリザベス
Elizabeth

アリッサ
Alyssa

ローレン
Lauren

イザベラ
Isabella

グレース
Grace

ジェシカ
Jessica

ブリアナ
Brianna

テイラー
Taylor

ケイラ
Kayla

アナ
Anna

ビクトリア
Victoria

メガン
Megan

シドニー
Sydney

クロエ
Chloe

レイチェル
Rachel

ジャスミン
Jasmine

ソフィア
Sophia

ジェニファー
Jennifer

モーガン
Morgan

ナタリー
Natalie

ジュリア
Julia

ケイトリン
Kaitlyn

ヘイリー
Hailey

デスティニー
Destiny

ヘイリー
Haley

キャサリン
Katherine

ニコル
Nicole

アレキザンドラ
Alexandra

マリア
Maria

サバンナ
Savannah

ステファニー
Stephanie

ミア
Mia

マッケンジー
Mackenzie

アリスン
Allison

アマンダ
Amanda

ジョーダン
Jordan

ジェナ
Jenna

フェイス
Faith

ペイジ
Paige

ミケイラ
Makayla

Boys' names

ジェイコブ
Jacob

マイケル
Michael

ジョシュア
Joshua

マシュー
Matthew

イーサン
Ethan

ジョセフ
Joseph

アンドリュー
Andrew

クリストファー
Christopher

ダニエル
Daniel

ニコラス
Nicholas

ウィリアム
William

アンソニー
Anthony

デビッド
David

タイラー
Tyler

アレキサンダー
Alexander

ライアン
Ryan

ジョン
John

ジェイムズ
James

ザッカリー
Zachary

ブランドン
Brandon

ジョナサン
Jonathan

ジャスティン
Justin

クリスチャン
Christian

ディラン
Dylan

サミュエル
Samuel

オースティン
Austin

ホ ゼ
Jose

ベンジャミン
Benjamin

ネーサン
Nathan

ローガン
Logan

キャビン
Kevin

ガブリエル
Gabriel

ロバート
Robert

ノ ア
Noah

キャレブ
Caleb

トーマス
Thomas

ジョーダン
Jordan

ハンター
Hunter

キャメロン
Cameron

カイル
Kyle

エライジャ
Elijah

ジェイソン
Jason

ジャック
Jack

アーロン
Aaron

アイザヤ
Isaiah

エンジェル
Angel

ルーク
Luke

コナー
Connor

ルイ(ス)
Luis

アイザック
Isaac

INDEX

AUTHOR'S ACKNOWLEDGMENTS
I would like to thank my masters, Kakko Nishii, Shisen Bota, and Tenshinkai Calligraphy Institution. Also my thanks go to Ms. Jimi Hara without whose support this book could not have been accomplished; and to my family, especially my late grandmother and mother who showed me the beauty of nature and calligraphy, and my sister who made norens. Special thanks go to Yomiuri Newspaper, Mr. Toun Kobayashi, Shoinji Temple, Fukuoka Art Museum, Kameya Suehiro, Tokyo National Museum, Nara National Museum, Toji Temple and Kita no Temmangu Shrine. Also, my special thanks go to Ms. Georgina Harris of Cico Books, Mr. Robin Gurdon and Mr. Geoff Dann.
PICTURE CREDITS
All photographs are by Geoff Dann and © Cico Books, except those which are © and reproduced with thanks to: Yomiuri Newspaper (page 8), Shoinji Temple (pp. 7, 85), Fukuoka Art Museum (p.17), Kameya Suehiro (p.9), Tokyo National Museum (pp.10, 12, 13, 14, 15, 16), Nara National Museum (p.87), Toji Temple (p.11) and Kita no Temmangu Shrine (p.9). Speical thanks to Sumi-e master Mr. Toun Kobayashi (pp. 84, 89 & other sumi-e patterns used as reference by the author.)